# TEMECULA VALLEY WINERIES

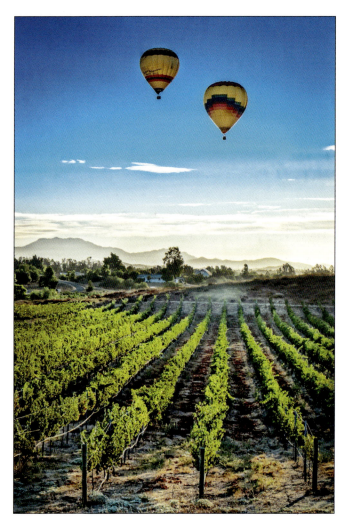

BALLOONS ABOVE THE VINEYARDS. Hot-air ballooning is one of the most unique and memorable activities for Temecula wine country visitors. For more than 40 years, balloons have been carrying passengers over the vine-covered hills, horse ranches, and other awe-inspiring scenery. One of the most popular events in wine country is the Balloon and Wine Festival, which takes place every May at the Lake Skinner Recreation Area. (Courtesy of Brian Reilly.)

FRONT COVER (TOP TO BOTTOM): Visitors at Altisima Winery celebrate another beautiful day in Temecula wine country. (Courtesy of Altisima Winery.) The changing colors of the grapevines throughout the year is one of the highlights of any visit to wine country. (Courtesy of Brian Reilly.)

UPPER BACK COVER: Sunsets in Temecula wine country are unforgettable. (Courtesy of Matthew Burlile.)

LOWER BACK COVER (FROM LEFT TO RIGHT): Marcelo Doffo tends his grape must during a harvest in the early days of his winery. (Courtesy of Doffo Winery.) Executive chef Ben Diaz visits with dinner guests at the Leoness Cellars' award-winning restaurant. (Courtesy of Antonio Correa.) Pictured is the door to one of the tasting rooms at Oak Mountain Winery. (Courtesy of Oak Mountain Winery.)

# TEMECULA VALLEY WINERIES

Rob Crisell
Foreword by Phil and Carol Baily

Copyright © 2023 by Rob Crisell
ISBN 978-1-4671-6036-0

Published by Arcadia Publishing
Charleston, South Carolina

Printed in the United States of America

Library of Congress Control Number: 2023934919

For all general information, please contact Arcadia Publishing:
Telephone 843-853-2070
Fax 843-853-0044
E-mail sales@arcadiapublishing.com

Visit us on the Internet at www.arcadiapublishing.com

*Dedicated to the winery owners, winemakers, and vine growers of Temecula Valley, past and present, whose passion and determination have made Southern California wine country a reality.*

# Contents

| | | |
|---|---|---|
| Foreword | | 6 |
| Acknowledgments | | 7 |
| Introduction | | 8 |
| Wine Country Map | | 10 |
| 1. | Temecula Wine Country's History and Pioneers | 11 |
| 2. | Rancho California Wine Trail | 27 |
| 3. | De Portola Wine Trail | 65 |
| 4. | Dining in Wine Country | 79 |
| 5. | Other Temecula Attractions | 89 |
| Winery Index | | 94 |
| Bibliography | | 95 |

# Foreword

Temecula Valley is a unique wine region with a rich history populated by an unusual cast of characters, whose indelible contributions are chronicled in this book. From documenting the larger-than-life Ely Callaway, whose audacity brought outsized early recognition, to John Moramarco, whose tireless efforts ensured that our wine country thrived and withstood the relentless pressures of urbanization, Rob has crafted a volume that deserves to be on the bookshelf of all who love wine.

We joined this cast of characters in 1981 when we decided to remake our lives and move to the country. Back then, the "country" was Temecula Valley, a former 100,000-acre cattle ranch that was being transformed into a residential community with an agricultural bent, the centerpiece of which was a 3,000-acre nascent wine region. As avid wine enthusiasts and home winemakers, we planted our first acre of grapes on Mother's Day in 1982. We expanded the vineyard to six acres in 1983, enrolling in courses at the University of California, Davis (UC Davis) in viticulture and enology.

In 1986, we opened our first winery with one wine for sale, a Cabernet Sauvignon made unconventionally using the carbonic maceration process. We chose this process because it was the fastest way to make a pleasing red wine, and we needed to reverse the cash flow. Thankfully, the wine was a big hit with our new customers.

Although there were a dozen wineries here by 1986, today we find ourselves as the only ones still operating under the same ownership. With our children and grandchildren functioning as integral parts of the operation, we hope to continue our tradition of making fine wines for many years to come.

We now have almost 50 wineries operating in the valley. Temecula has become known as a place whose wines can compare favorably to any in the world. Rob's book will provide insight into what has brought us to this point and what will drive our efforts to ensure our future success.

So, prop up the pillows on the couch, pour a glass of fine Temecula Valley wine, and settle down for an engaging look into what makes the Temecula Valley such a special place for growing grapes and making wine.

—Phil and Carol Baily

# Acknowledgments

With nearly 50 wineries and more than 200 years of history, Temecula wine country encompasses the knowledge, passion, and memories of generations of people. I am indebted to all those individuals who have dedicated their lives to developing the wineries and vineyards of Temecula. I especially want to thank Peter Poole, Phil and Carol Baily, Rebecca Farnbach, and Bev Moramarco. Without their generous help and expertise, this book would not have been possible.

I thank the many winery owners, photographers, winemakers, and institutions that sent me photographs and marketing material, especially the De Portola Wine Trail Association and the staff of the Temecula Valley Winegrowers Association (TVWA), including Krista Chaich, Bianca Castillo, and Shonnah Noll. My thanks go to Rick and Jennifer Buffington, the Cilurzo family, Darell Farnbach, Bill and Eric Filsinger, Jim Hart, Wendy Holder, Roger Honberger, Tim Kramer, Craig Larson, Jon McPherson, Mike Menghini, Dennis Munyon, Greg Pennyroyal, John and Jeanell Piconi, Ernie and Norma Tavizon, Mike Tingley, Joe Vera, and Art Villarreal. I thank Matthew Burlile and Brian Reilly for allowing me to use their stunning photographs on the front and back covers. I also need to express my gratitude to my editor Caroline (Anderson) Vickerson for her patient assistance throughout the writing process.

My thanks also go to the City of Temecula, Temecula Valley Museum (especially Daniel Morales), Cal Poly Pomona Special Collections, Small Winegrowers Association, Temecula Public Library, Temecula Valley Wine Society, and the Temecula Valley Historical Society. All photographs taken by me are credited as RC.

Finally, I thank my wife, Monisha, for her unwavering support and love. To quote that notorious enophile William Shakespeare, she makes "the coming hour o'erflow with joy, and pleasure drown the brim."

# Introduction

If you are reading this, you may have already discovered the singular oasis that is Temecula Valley wine country. Every year, more than two million people enjoy the area's peaceful valleys, scenic views, resort-style dining and entertainment, and gorgeous wineries set among 2,500 acres of vineyards. Compared to California's more famous wine regions to the north, Temecula was relatively unknown until a decade ago. Not anymore.

As with most American stories, the history of Temecula wine country begins with the aboriginal peoples of the region. The origin of the name has been variously translated from the language of the Luiseño (or Payómkawichum) as the "place of sun and sand" or "where the sun shines through the mist." The nomadic tribes that first made their homes in the valley more than 7,000 years ago were and are fiercely independent, representing as many as 100 distinct cultures.

Europeans arrived in California in earnest with the Gaspar de Portola expedition from Baja California in 1769. That year, De Portola and Fr. Junipero Serra established the first of the state's missions at San Diego. Although he is often credited with planting the state's first vines, Serra did not bring grape cuttings with him. In 1779, one of the friars at Mission San Juan Capistrano wrote of receiving vine cuttings "from the lower country." Scholars believe California's first vintage was made at San Juan Capistrano in 1782. Ten years later, there were abundant vineyards and winemaking facilities at the San Gabriel, San Luis Obispo, and San Fernando missions. The only grapevine planted for the next century was the "Mission grape" (Criolla or Listan Prieto).

In 1798, Fr. Francisco de Lauséun founded Mission San Luis Rey de Francia, which lends its name to the Luiseño Indians who lived in the region. Under Fr. Antonio Peyrí, this "King of the Missions," located near modern-day Oceanside, California, depended heavily upon its rancho in Temecula. By the 1830s, Temecula Valley likely supplied most of the mission's grain and cattle and almost certainly some of its wine grapes. At least 60 acres of grapes were in cultivation at San Luis Rey and perhaps as many in nearby Pala, where the friars had built an *asistencia* or sub-mission. Temecula had a smaller asistencia as well, along with its own vines. Winemaking and the distilling of brandy played a significant role in the economics of the missions.

The 1880s witnessed the arrival of a new wave of European immigrants, especially from France and Italy. Many settled in Temecula Valley, some marrying into the Pechanga tribe. Between 1880 and 1920, families such as Cazas, Escallier, Borel, Hunter, and Pourroy planted vineyards and made wine on their properties. The Escallier and Cazas families sold wine before and during Prohibition in stores on Pala Road and in Old Town Temecula. Today, vineyards planted in the early 1900s can still be seen on what is now the Pechanga Reservation.

In 1904, Walter Vail purchased 87,500 acres of the Temecula, Pauba, Santa Rosa, and Little Temecula land grants. For more than 50 years, his son Mahlon Vail and the Vail Company ran a massive cattle and grain operation in the valley. In 1964, the Vail family sold the property to Kaiser-Aetna Development Company, which renamed the area Rancho California and began subdividing the land for real estate development.

When the Volstead Act was passed in 1919, San Bernardino and Riverside Counties were home to tens of thousands of acres of vineyards. While Prohibition led to the closure of the vast majority of the state's 720 wineries, grape growing, home winemaking, and outright bootlegging thrived. With the repeal of Prohibition in 1933, the Cucamonga region expanded its vineyards. When the post-World War II economic boom began to displace agricultural land, Philo Biane—owner of Brookside Vineyard Company and Guasti Winery—began to search for less expensive land on which to plant his grape vines.

In 1966, to help attract potential buyers, Kaiser hired Dick Break, a UC Davis–trained specialist in viticulture, to plant blocks of vines to show the viability of grape growing. These demonstration vineyards were divided into four separate 10-acre parcels on Rancho California and De Portola Roads. Kaiser reached out to Biane about having Brookside plant vines. Biane found that Temecula's climate and the cool ocean breeze that flowed through the Santa Margarita Gap (often nicknamed the "Rainbow Gap") during summer made the area ideal for grape growing. He bought 400 acres along Rancho California in the heart of wine country.

In 1968, pioneering viticulturist John Moramarco planted the Brookside land as well as 80 acres of vines for Vincenzo and Audrey Cilurzo, who later founded Cilurzo Vineyard and Winery. McMillan Farm management planted vineyards as well, hiring Temecula pioneers Leon Borel, Enrique Ferro, and Ben Drake.

In 1969, two ambitious, wealthy men moved to Temecula and changed everything. One was Ely Callaway, the former president of Burlington Mills who had been bitten by the wine bug. The other was John Poole, owner of several large radio stations in the state. Each separately purchased 100 acres next to each other, which Moramarco planted in vines. By 1970, Temecula was home to more than 1,000 acres of vineyards.

At first, most Temecula grapes were sold to wineries in Rancho Cucamonga or the North Coast. In 1974, however, Callaway Winery produced the first wines made in Temecula from Temecula grapes. By the end of the decade, Callaway had put Temecula on the map with its aggressive marketing campaigns and national sales. Over the next two decades, Callaway would purchase more than 50 percent of all fruit grown in Temecula and produce more than 300,000 cases per year.

In 1975, John Poole opened Mount Palomar Winery, which became the first to emphasize sales to visitors. In 1978, Dr. John Piconi and the Cilurzos opened Cilurzo Piconi Winery. Wineries slowly began to multiply in the 1980s as Temecula's population grew. William Filsinger and Joe Hart came next, followed quickly by Piconi (on his own), Phil and Carol Baily, Budd and Maurice Van Roekel, John and Martha Culbertson, John Thornton, and Carl Key. These wine country founders took great pride in their tight-knit community of small vintners and growers. By the end of the decade, Temecula had 15 wineries, nearly 3,000 acres of vines, and more visitors than ever before.

Then disaster struck. In 1997, Temecula's vines began dying of what seemed to be acute dehydration. Experts soon identified the problem as Pierce's Disease—a deadly and incurable bacteria-induced vine disorder that blocks water absorption. The new plague was being spread by a non-native insect, the glassy-winged sharpshooter. Sharpshooters carried diseased bacteria from plant to plant, effectively killing vines before symptoms could be detected. The region's thriving grape export business disappeared overnight. By 2001, the disease had wiped out more than 60 percent of the area's vineyards.

Wineries and growers went to work to tackle the crisis. They began strict monitoring programs, spraying of adjacent citrus groves where the sharpshooter resides, and preventive injections of insecticide into the vineyard irrigation systems. Happily, vineyards were replanted in a wealth of new varietals, especially Rhone grapes such as Syrah, Grenache, Viognier, and Mourvèdre, but also Spanish, French, and Italian varietals like Sangiovese, Tempranillo, Pinot Grigio, Vermentino, Cabernet Sauvignon, and Zinfandel.

As Southern California's population soared in the 2000s, the number of wineries in the valley rose quickly as well. Since 2000, more than 30 new wineries have been built. Others have been resold, renovated, or expanded. Within the next two decades, it seems inevitable that another 50 wineries will be built, along with dozens of vineyards, restaurants, spas, and entertainment venues.

In the meantime, the wineries of Temecula Valley will keep striving for excellence, as creative owners and winemakers compete to provide visitors with the best wine experiences in the world. *Salute!*

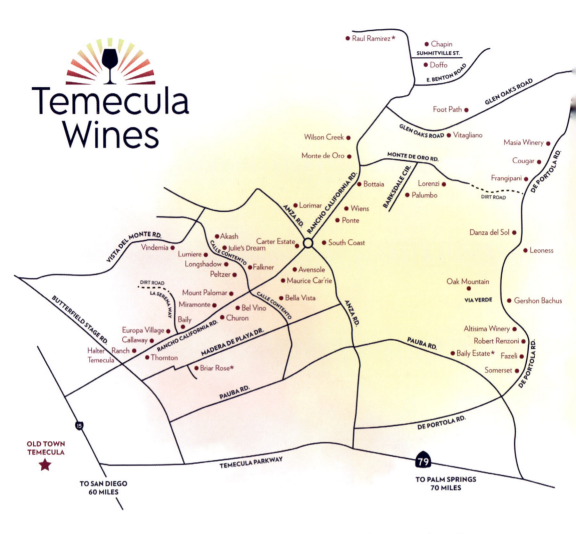

WINE COUNTRY MAP. As shown on the official map of the Temecula Valley Winegrowers Association, most of Temecula's wineries are found along two roads. To the north, Rancho California Wine Trail follows Rancho California Road east from Butterfield Stage Road to Lake Skinner. To the south, De Portola Wine Trail follows De Portola Road from Anza Road until it meets Glen Oaks Road. (Courtesy of TVWA.)

# One
# Temecula Wine Country's History and Pioneers

MISSION SAN LUIS REY DE FRANCIA. Some have said that the history of wine is the history of civilization. When the first Franciscan missionaries brought the humble Listan Prieto (or "Mission") grape to Southern California in the late 18th century to make wine for the Eucharist, they could not have predicted that one of their outposts—Rancho Temecula—would become a popular wine destination in a city of more than 125,000 people. The history of Temecula Valley wine country is the story of how Indigenous peoples; Spanish, Mexican, and European immigrants; and intrepid Americans transformed a sleepy community between Los Angeles and San Diego into one of the fastest-growing wine regions in the world. It is a story of booms and busts, of farmers and businesspeople, of risk-takers and romantics. (Courtesy of Marelbu.)

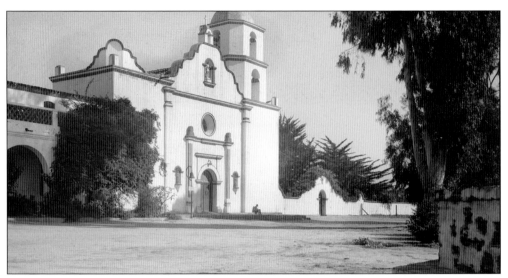

THE KING OF THE MISSIONS, C. 1933. Founded in 1798, Mission San Luis Rey exerted a powerful influence, both positive and negative, on the Indigenous peoples of the area. Under Father Peyrí, the so-called "King of the Missions" spurred the development of Temecula Valley as an agricultural region. Although located 28 miles away, Rancho Temecula supplied much of the mission's grain and provided pastureland for its cattle. While nearby Mission San Juan Capistrano made California's first vintage in 1782, San Luis Rey was producing 2,500 barrels of wine and brandy annually by 1831. (Public domain.)

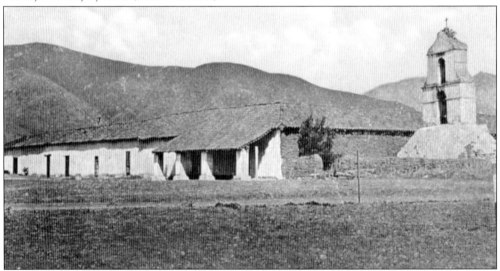

VINTAGE POSTCARD OF MISSION SAN ANTONIO DE PALA, C. 1905. Built in 1816 by the friars as a sub-mission (asistencia) of San Luis Rey, San Antonio de Pala served the local Luiseño Indians. At least 30 acres of vineyards existed here by 1830. Pala likely supplied grapes for winemaking at the main mission 20 miles away. By 1821, a smaller asistencia had been built in Temecula. The seven-mile road between Pala and Temecula Valley was the main route used by Indians and settlers alike well into the 20th century. San Antonio de Pala is the only historic mission facility still serving a mission Indian tribe. The Indians of Temecula Valley referred to themselves as the Temeku or, later, the Pechanga people. Pablo Apis, a Luiseño Indian, mentioned "150 stocks of vines" in his 1850s lawsuit to retain ownership of 2,200 acres in Temecula Valley. (RC.)

JACQUES ESCALLIER HOUSE, C. 1920 AND TODAY. In 1886, French immigrant Jacques Escallier settled just south of Temecula on Pala Road, marrying a Pechanga woman named Dominga Ayal. The Escalliers became one of the founding families of Temecula. The Escallier house may have served as a general store and winery where the area's first commercial wines would have been made and sold. Eventually, the Escalliers relocated to Old Town. In 1969, the ruins of the old house—which was destroyed by fire in 1923—and surrounding buildings were purchased by Temecula's celebrated vineyard manager John Moramarco. Large Mission and Zinfandel grapevines on the property date to the Escalliers' original vineyards, if not earlier. Bev Moramarco—wife of John and a former executive with Callaway Winery—still lives on the property with her family. The house is not far from the historic Cazas and Hunter vineyards. (Above, courtesy of Rebecca Farnbach; below, RC.)

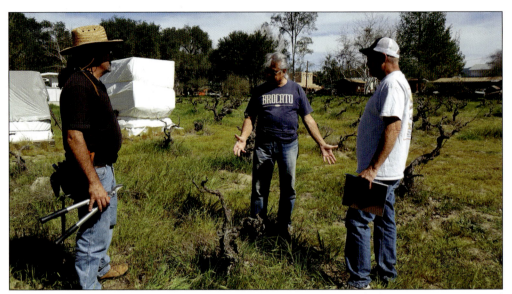

ERNIE TAVIZON AND HUNTER VINEYARD. Ernie Tavizon (center), owner of the historic Hunter Vineyard on the Pechanga Indian Reservation with his wife, Norma, talks with Greg Pennyroyal (left) and Jim Hart. Tavizon recalls seeing the vines as a child with his grandmother, uncle, and cousins. Like the Cazas vineyard nearby, the Hunter property was likely planted in the early 1900s or before and was originally much larger than it is today. Thanks to the passion and dedication of Tavizon, Pennyroyal (Wilson Creek Winery's tireless vineyard manager), and Hart (former owner of Hart Winery), these 120-year-old Mission vines once again produce wine. (Courtesy of Ernie Tavizon.)

CAZAS VINEYARD. Located on the Pechanga Indian Reservation, only two acres remain of a 22-acre vineyard originally planted by Felipe Jesus Cazas in the late 1800s. According to Roger Honberger—great-grandson of Cazas and part owner of the vineyard—the vines were planted from original Mission grape cuttings from Mission San Luis Rey. Felipe and his wife, Louisa (Ayal) Cazas, made wine in a building near his trading post not far from their Escallier relatives on Pala Road. (Courtesy of Roger Honberger.)

FRENCH VALLEY FARMERS AND VINTNERS, c. 1930. In the 1880s, French immigrant farmers such as Rosalie and Alexander Borel (left) and Pierre and Mary Pourroy (right) began to settle in Temecula Valley. The Borel and Pourroy families farmed hundreds of acres in what became known as French Valley, northwest of present-day wine country. Many French and Italian families grew vineyards and made wine commercially before and during Prohibition. The Borel family reportedly produced around 1,000 gallons per year during the 1920s and 1930s. (Courtesy of Temecula Valley Museum.)

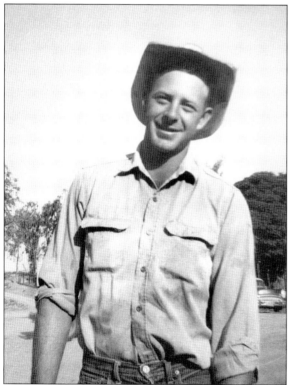

LEON BOREL, C. 1960. The grandson of Alexander Borel Sr., Leon Borel was the third generation of his family to farm the French Valley. He grew up working the family vineyards and helping to make wine. In 1965, Dick Break—newly commissioned by the Kaiser Aetna Development Company to plant a variety of crops (including grapes) in the valley to entice potential buyers—hired Borel as his farm manager. Break and Borel helped plant the first demonstration vineyards in 1966. Borel later planted vines for the McMillan Farm Management Company before striking out on his own. In 1984, he built the French Valley Winery on his family's land on Winchester Road, operating it for a short time before he retired. The building now serves as a lodge for a fraternal organization. (Courtesy of Temecula Valley Museum.)

15

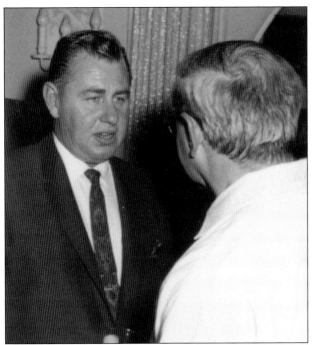

**DICK BREAK PLANTS WINE COUNTRY'S FIRST VINES.** In 1966, Kaiser hired a viticulture specialist named Dick Break, a graduate of UC Davis. Two years later, Break and his vineyard manager Leon Borel supervised the planting of around 40 acres of vines in four different blocks along Rancho California and De Portola Roads. Break was among the first in the post-Prohibition era to recognize Temecula Valley's potential for premium wine grapes. Here, he speaks with Vincenzo Cilurzo. (Courtesy of Temecula Valley Museum.)

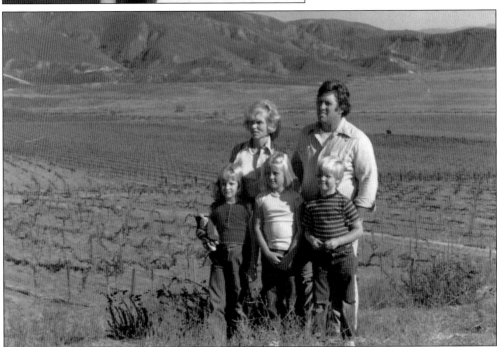

**DEMONSTRATION VINEYARD ON DE PORTOLA ROAD, C. 1974.** In 1971, Dennis and Patricia Munyon (shown on their property with their family) bought one of the four demonstration vineyards planted in 1966. In 1972, Dennis became vice president of the Rancho California Wine Growers Association, the first such organization in the valley. For several years, Dennis sold his grapes to home winemakers in Los Angeles and Orange Country. The remains of the original vineyards are now part of Somerset Vineyard and Winery. (Courtesy of Dennis Munyon.)

JOHN MORAMARCO, WINEGROWER. John Moramarco worked for Brookside Winery after arriving in the area from Ontario in the mid-1960s. He soon joined Callaway Winery as its vineyard manager, planting vines for Callaway, Poole, and others in the valley. He ultimately became the general manager at Callaway. Moramarco led the effort to merge the Temecula winery and vineyard associations into the Temecula Valley Winegrowers Association. As a wine country leader for more than three decades, Moramarco was a mentor to dozens of winegrowers until his death in 2016. (Courtesy of Bev Moramarco.)

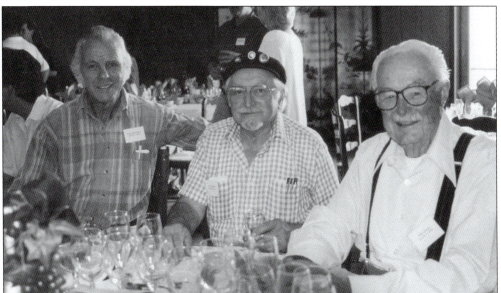

WINE PIONEERS REUNITE, MID-1990S. In 1966, Philo Biane (far right)—owner of Brookside and Guasti Wineries in the Ontario area—purchased 400 acres along Rancho California Road. In 1968, he hired John Moramarco (far left) to plant them. Moramarco also planted the acreage of Vincenzo Cilurzo (center) around the same time. Biane's investment in Temecula wine country encouraged other growers to take a chance on the area. In 1984, the Ponte family bought Brookside's holdings, eventually building Ponte Winery and Bottaia Winery. (Courtesy of Temecula Valley Museum.)

**AUDREY AND VINCENZO CILURZO, C. 1968.** In 1966, Vincenzo Cilurzo was an Emmy award–winning lighting director in Hollywood, responsible for the *Merv Griffin Show* and *Jeopardy*. He and his wife, Audrey, however, dreamed of a more bucolic lifestyle. In 1966, they purchased 100 acres on Rancho California Road, then known as Long Valley Road. In 1968, with the assistance of John Moramarco and Dick Break, they planted their first vineyards on the property. (Courtesy of Temecula Valley Museum.)

**THE CILURZOS WITH THEIR WINES, C. 2003** In 1978, Audrey and Vincenzo Cilurzo built the Cilurzo Piconi Winery with local physician and winemaker John Piconi on Calle Contento Road. It became the third winery in Temecula to produce its own wines. When Piconi started his winery in 1981, the Cilurzos remained wine country fixtures until they sold their winery in 2004 to Imre and Gizella Cziraki, who renamed it Bella Vista Winery. (Courtesy of Cilurzo family.)

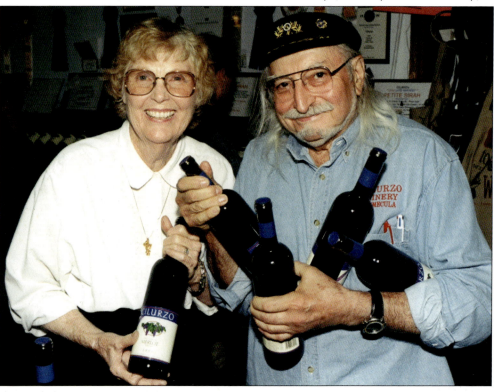

JOHN MORAMARCO AND ELY CALLAWAY, c. 1980. In 1974, Ely Callaway (right) became the first to open a winery in Temecula, relying heavily on vineyard manager John Moramarco (left). Callaway and Moramarco deserve much of the credit for the early success of Temecula wine country. Pioneers Joe and Nancy Hart can be seen in the foreground. (Courtesy of Jim Hart.)

ELY CALLAWAY. The former president of Burlington Industries, Ely Callaway believed passionately in Temecula's potential as a wine region. His extraordinary vision, commitment to producing fine wines from local fruit, and legendary marketing skills brought national attention to Temecula as a wine region. After selling his winery in 1981, he went into the golf club business. The success of his "Big Bertha" clubs made Callaway Golf the number-one golf company in the world. (Courtesy of Callaway Winery.)

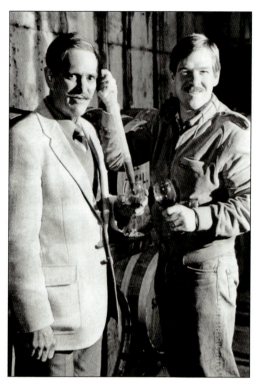

JOHN AND PETER POOLE IN MID-1980s. In 1969, radio station owner John Poole (left) planted vineyards on his 165 acres, including some of the region's earliest plantings of Syrah. In 1975, he built Mount Palomar Winery, Temecula's second winery and the first specifically designed to host visitors. A permanent tasting room was added in 1978. By then, Peter Poole had joined his father, taking over operations by the mid-1980s. When the Poole family sold the winery in 2006, Peter became a vineyard consultant and professor of viticulture. John and Peter Poole are members of the Temecula Valley Winegrowers Hall of Fame. (Courtesy of Peter Poole.)

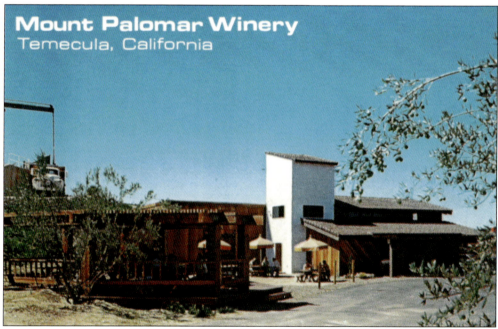

MOUNT PALOMAR WINERY, C. 1976. When Peter Poole took over as general manager in 1989, he made several innovations that helped modernize Mount Palomar Winery. He updated its winemaking program under winemaker Etienne Cowper and cultivated the valley's first Sangiovese and Cortese vines. As this postcard indicates, Mount Palomar was also the first winery to begin advertising Temecula as a tourist destination. (RC.)

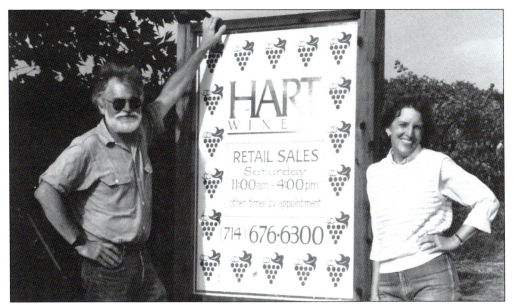

Joe and Nancy Hart. Wine country pioneers Joe and Nancy Hart planted the first vines on their eight-acre property at the entrance of wine country in 1974. They opened a simple, barnlike winery to the public in 1980, becoming the fifth winery in Temecula. Hart Winery produced over 40 vintages until Joe's death in 2021. The Hart family sold the winery to Halter Ranch shortly after Joe's passing. In addition to being one of the area's top winemakers, Joe was an educator, leader, and mentor within the wine community. (Courtesy of Jim Hart.)

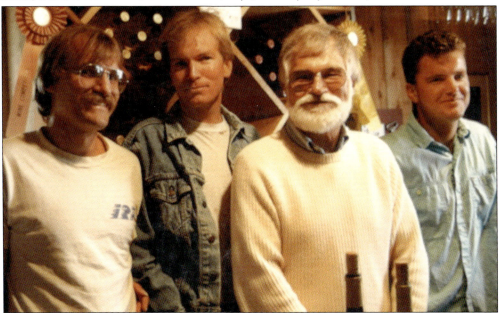

Joe Hart and his Boys. Nancy and Joe Hart's children were heavily involved in the Hart Winery from the beginning. Bill (far right) worked with his father as assistant winemaker for many years. Jim (second from left) eventually took over as winemaker and operations manager. Since 2015, Mike (far left) and Jim have owned Volcan Mountain Winery in Julian, California, where they continue their father's legacy of making fine wines. (Courtesy of Jim Hart.)

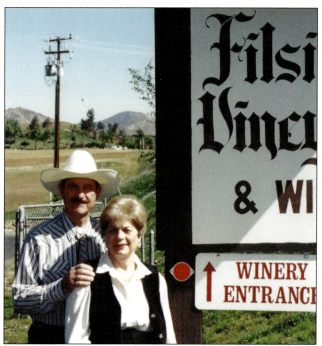

DR. WILLIAM AND KATHY FILSINGER. In 1974, Orange County physician William Filsinger and his wife, Kathy, purchased 35 acres of vineyards on De Portola Road. When Filsinger Winery opened its doors in 1980, it became the first establishment on the De Portola Wine Trail and the fourth winery in the valley. Winemaker Mike Menghini made Filsinger Winery's first vintages. Filsinger took over winemaking duties in 1986, assisted by his son Eric. Filsinger Winery became one of only two places in Temecula to make sparkling wines using the traditional *méthode champenoise* technique. In 2010, Filsinger sold his winery and retired. It is now Danza del Sol Winery. (Courtesy of William Filsinger.)

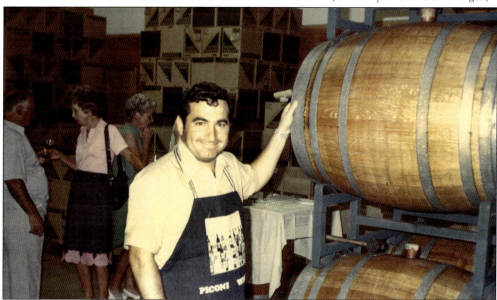

DR. JOHN PICONI AT WINERY'S GRAND OPENING, 1981. Fallbrook urologist John Piconi somehow found time to practice medicine, help raise six children, and manage a winery at the same time. In 1978, he partnered with Vincenzo and Audrey Cilurzo to build Cilurzo Piconi Winery, producing a Cabernet Sauvignon and a Petite Sirah. In 1981, he opened his own place on seven acres along Rancho California Road between Callaway and Mount Palomar Wineries. At its peak, Piconi Winery produced 6,000 cases per year, including Southern California's first wines made from the modern varietal Carmine. Piconi's wines consistently earned top awards in competitions around California. In 1999, Piconi sold the property to Cane Vanderhoof, who renamed it Miramonte Winery. Now 83, Piconi still makes wine every year. (Courtesy of John Piconi.)

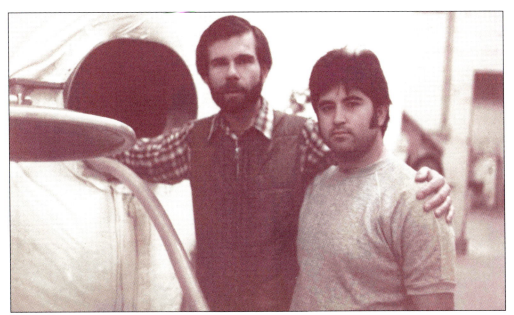

MASTER WINEMAKERS MIKE TINGLEY AND ART VILLARREAL, C. 1983. Two of Temecula's most accomplished winemakers, Mike Tingley and Art Villarreal, both began their careers at Callaway Winery in the late 1970s. In 1983, Tingley left to join Cilurzo Winery as its first winemaker. He spent much of his career with Maurice Car'rie Winery. Before retiring in 2021, he worked as a consultant for Danza del Sol, Keyways, Lorimar, Gershon Bachus, and others. Villarreal spent most of his 45-year career at Callaway, ultimately becoming head of winemaking. After a four-year stint at Gary Farrell Winery in Sonoma, Villarreal finished his career at Danza del Sol. (Courtesy of Art Villarreal.)

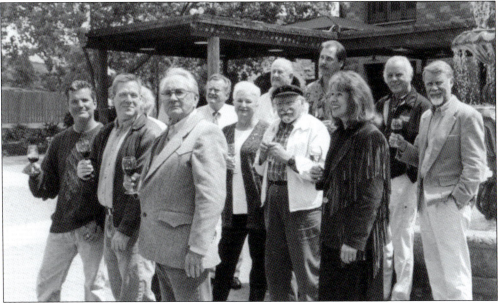

WINERY OWNERS, MID-1990S. Most of the area's winery owners gather for a photograph at Thornton Winery during an association meeting. From left to right are (first row) Bill Hart, Peter Poole, and Carl Key; (second row) John Thornton, Maurice Van Roekel, Vincenzo Cilurzo, and Carol Baily; (third row) Budd Van Roekel, Marshall Stuart, John Moramarco, and Phil Baily. (Courtesy of TVWA.)

BEN DRAKE, TEMECULA ICON. For more than 40 years, farm manager, winegrower, and vintner Ben Drake held a number of leadership roles in Temecula Valley. With Leon Borel and John Moramarco, he planted much of the agricultural acreage in Temecula in the 1970s. Later, he served as president of the Temecula Valley Winegrowers Association, crafting responses to the crisis of Pierce's Disease. He was a board member of the California Association of Wine Grape Growers, earning that organization's Leader of the Year award in 2013. He also guided water policy in his role as president of various water boards. After his death in 2018, he was inducted into the Temecula Valley Winegrowers Hall of Fame. (Courtesy of J.D. Harkey.)

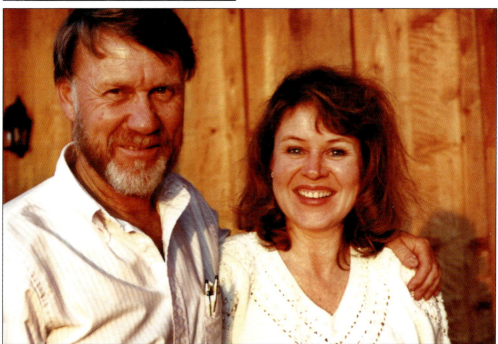

PHIL AND CAROL BAILY IN THE MID-1980S. After moving to Temecula from San Marino in 1982, Phil and Carol Baily planted their first two acres of vines (Riesling) and took enology courses at UC Davis. In 1986, they built a winery on a dirt road not far from De Portola Road. They became fast friends with other wine country founders, such as the Cilurzos, Moramarco, Piconi, Hart, Filsinger, and Poole. After Joe Hart's passing in 2021, Phil and Carol Baily are the last pioneers still in wine country. In 2021, *Reader's Digest* named Baily Winery as one of the top 25 wineries in the United States. (Courtesy of Phil and Carol Baily.)

MASTER WINEMAKER JON MCPHERSON. When Jon McPherson (or "Jonny Mac," as he is often called) arrived from Texas in 1985 to lead sparkling wine production at Fallbrook's Culbertson Winery, there were only 10 wineries in Temecula. When Culbertson Winery came to Temecula and later became Thornton Winery, McPherson continued making both sparkling and still wines. After 14 years at Thornton, Jim Carter hired McPherson and Javier Flores to be the founding winemakers at South Coast Winery Resort & Spa. McPherson has made more than 40 vintages and counting. Many consider him to be among the most accomplished winemakers in California. (Courtesy of South Coast Winery Resort & Spa.)

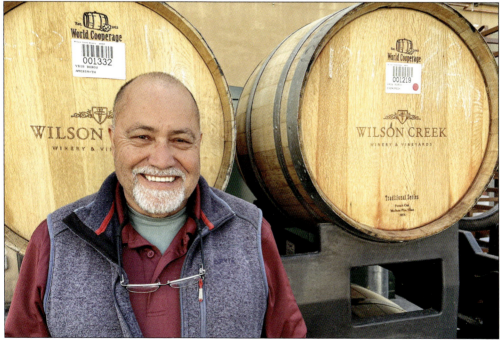

JOE VERA, CELLAR MASTER. Joe Vera has spent more years working in the vineyards of Temecula than anyone else on Earth. Since immigrating from Jalisco, Mexico, with his parents in the mid-1960s, Vera has participated in 53 harvests in the valley. After 32 years as cellar master at Callaway Winery, Vera is now "king cellar rat" at Wilson Creek Winery, where he works with vineyard manager Greg Pennyroyal and winemakers Gus Vizgirda and Kristina Filippi. (Courtesy of Wilson Creek Winery.)

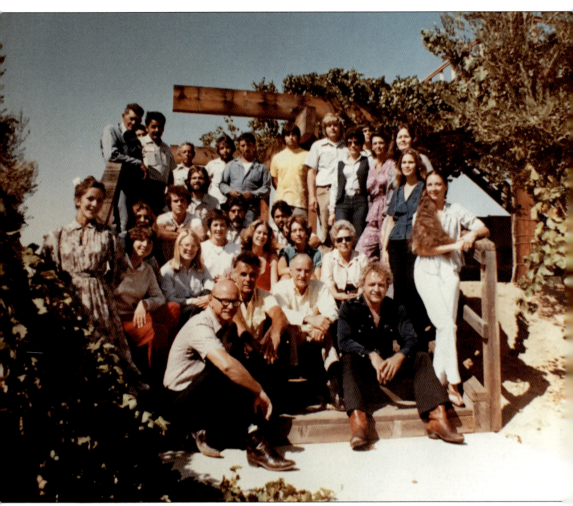

**Ely Callaway and Staff, c. 1980.** Caption TK. Callaway Winery owner Ely Callaway and his vineyard manager John Moramarco (front row, seated at center) pose with winery staff. Several wine country icons in this photograph spent their formative years at Callaway Winery, like winemakers Mike Tingley and Art Villarreal, cellar master Joe Vera, and future winery executive Bev Moramarco. In 1981, Callaway sold his winery to the Hiram Walker Corporation. At its height in the late 1990s, Callaway Winery produced more than 300,000 cases annually for national distribution. One event that catapulted Callaway into the national consciousness took place in 1976 when Queen Elizabeth II toasted Pres. Gerald Ford at a luncheon at the Waldorf-Astoria Hotel in New York City. The only wine served at the event was Callaway's 1974 White Riesling. Famously, the queen requested a second glass. (Courtesy of Mike Tingley.)

# Two
# Rancho California Wine Trail

LOOKING EAST ALONG RANCHO CALIFORNIA ROAD. The Rancho California Wine Trail is the longer and more established of the two wine roads in Temecula. It begins at Butterfield Stage Road and continues east, ending at Lake Skinner. Once known as Long Valley Road, most Temecula wineries are found along its six-mile length or on one of several side roads, such as Calle Contento, Monte De Oro, and Glen Oaks. Wineries on Rancho California are located on the valley floor or on gently sloping hillsides. Vineyard and mountain views abound. These wineries tend to be larger and busier, with more services and amenities, compared to those along De Portola Wine Trail to the south. (RC.)

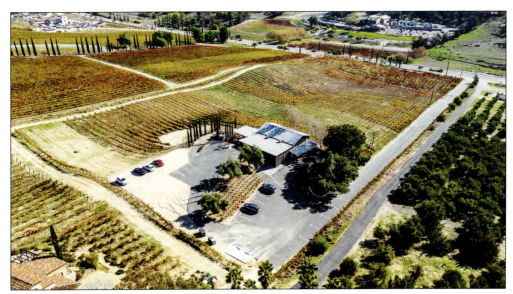

HALTER RANCH TEMECULA. When Halter Ranch purchased Hart Winery in May 2022, it acquired one of Temecula's first—and most beloved—wineries. Joe and Nancy Hart planted their first vines on the eight-acre property in 1974, opening to the public in 1980. The boutique winery at the entrance of the Rancho California Wine Trail long enjoyed a well-earned reputation for both its red and white wines, particularly Syrah, Cabernet Franc, and Sauvignon Blanc. When Joe passed away in 2021, Nancy, sons Jim and Mike, and the rest of the family chose to entrust Halter Ranch of Paso Robles, which has a stellar reputation for winemaking and viticulture. (Courtesy of Halter Ranch Temecula.)

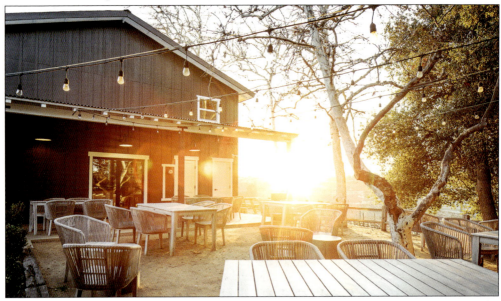

A NEW DAY DAWNS. Halter Ranch Temecula has already made several improvements to the property, rehabilitating the original 1980 structure and revitalizing aspects of the vineyards. Over the next year, Halter Ranch plans to expand indoor and outdoor seating for guests and install a chef's kitchen for a dining experience reflective of the same farm-to-table values as its Paso Robles location, while Halter Ranch's winemaker Kevin Sass will continue to make most wines from Temecula fruit. (Courtesy of Halter Ranch Temecula.)

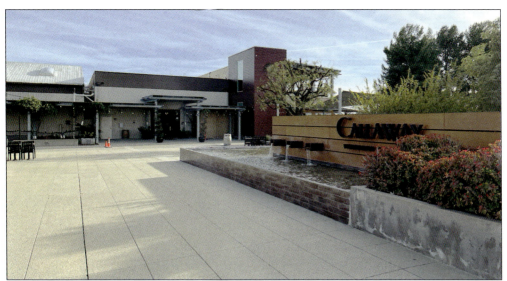

CALLAWAY VINEYARD AND WINERY. Founded in 1969, Callaway was the first winery in Temecula. It opened in 1974 in a single-wide trailer atop 150 acres of vines on Rancho California Road. Founder Ely Callaway eventually built a massive production facility and winery that is still larger than almost any other structure in wine country. At its peak, Callaway Winery produced more than 300,000 cases of wine annually, nearly all of it Chardonnay. When Callaway sold in 1981, his winery was producing as much wine as all other Temecula wineries combined. (RC.)

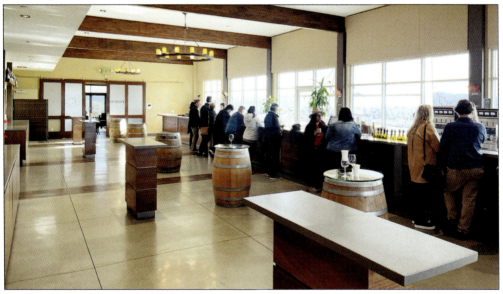

THE LIN FAMILY ERA. In 2005, San Diego real estate investor Patricia Lin purchased Callaway Winery. Although Lin had no experience in the wine industry, she had impressive vision and plenty of business savvy. She and her family soon renovated the gift shop, restaurant, and tasting rooms, adding a second story for wine club members. They also scaled back wine production from 100,000-plus cases per year to 15,000. While Callaway historically produced mostly white wines, today it makes more than two dozen different red, white, rosés, and sweet wines. Former winemaker Craig Larson championed the cultivation of southern Rhone varietals such as Syrah, Roussanne, Grenache, Viognier, and Mourvèdre. (RC.)

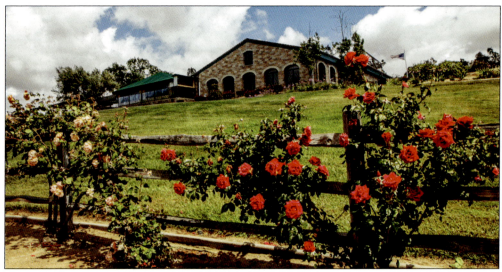

THORNTON WINERY. With its striking French Chateau architecture, Thornton Winery is among the most recognizable structures in Temecula. When it opened in 1988, Thornton was one of only 10 or so wineries in Temecula, with an enviable location at the entrance to wine country. From the beginning, the winery has been known for its sparkling wines, which are produced with the traditional *méthode champenoise* technique. In the 1990s, Thornton began to make reds and whites. Café Champagne offers casual dining for lunch and dinner seven days a week. (Courtesy of Thornton Winery.)

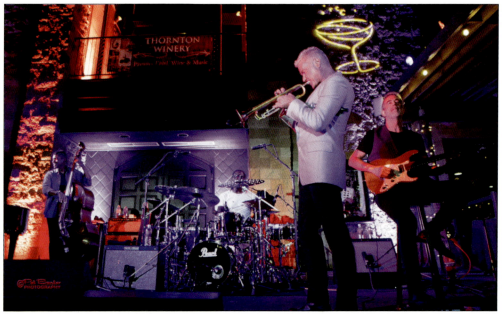

WINE AND JAZZ. Thornton Winery is famous for its Champagne Jazz concert series, which brings in well-known musicians from around the country. For more than three decades, the series of outdoor concerts has attracted thousands of visitors every summer. Artists such as Kenny G, Boz Skaggs, George Benson, Al Jarreau, David Sanborn, and Bruce Hornsby are regular guests. Thornton is still family owned, with Steve Thornton acting as current president. (Courtesy of Thornton Winery.)

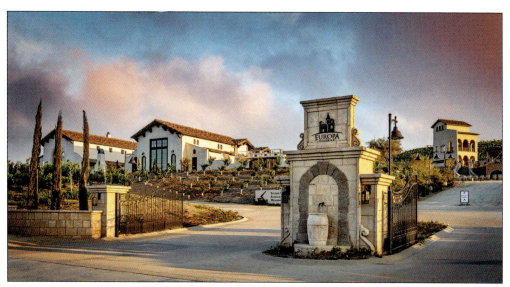

EUROPA VILLAGE WINERIES AND RESORT. Located near the entrance of wine country, Europa Village is composed of three interconnected wine "villages." Each is a winery resort representing one of the three largest wine regions in the world: France, Spain, and Italy. C'est La Vie features idyllic rose gardens within a picturesque courtyard. Like the ambience, wines are French inspired. The second winery is Bolero, which opened its tasting room and Spanish-themed restaurant in 2020. Once completed, Italian-themed Vienza will offer accommodations, shops, a market and delicatessen, event space, a tasting room, and a pool and spa. (Courtesy of Europa Village Wineries and Resort/Jimmy Fu Photography.)

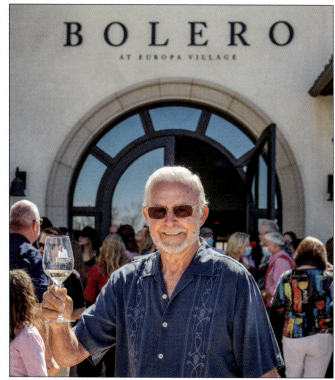

EUROPA VILLAGE FOUNDER DAN STEPHENSON. When it opened in 2020, Bolero Restaurante (shown here behind Dan Stephenson) instantly became one of the most sought-after fine-dining experiences in wine country. With its adjacent tasting room, gift shop, and event spaces, it is the culinary heart of Europa Village. The restaurant specializes in tapas-style dishes that pair perfectly with its Spanish wines, made by Europa's winemaker George Bursick. Wines include Garnacha, Verdejo, Cabernet Sauvignon, and red blends. Guests can eat inside the sleek restaurant or on the patio near the olive and cypress trees. (Courtesy of Europa Village Wineries and Resort/Jimmy Fu Photography.)

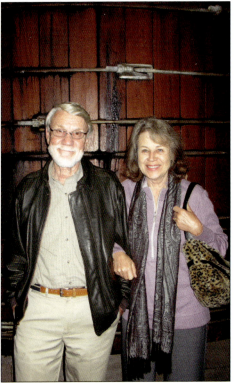

BAILY WINERY. Baily Winery is one of Temecula's most established wineries, opening to the public in 1986. Winemaker Phil Baily makes wine with an eye to the Old World and a focus on Bordeaux varietals, especially Cabernet Sauvignon, Cabernet Franc, Malbec, and Merlot. His whites are Sauvignon Blanc, Semillon, Chardonnay, and Riesling. Baily ages his reds longer than most Temecula winemakers, often keeping wines in barrel or bottle for at least 30 months. His wines are often complex, balanced, and occasionally rustic with tremendous depth and flavor. (Courtesy of Baily Winery.)

PHIL AND CAROL BAILY. The Bailys are typical of the first generation of Temecula vintners. After planting their first two acres in 1982, they took extension courses in enology. For 35 years, Phil and Carol have been leaders in the wine community, holding offices with the Temecula Valley Winegrowers Association, of which Phil is the current president. Carol has helped open three restaurants, including Carol's Restaurant at their tasting room on Rancho California Road. (Courtesy of Baily Winery.)

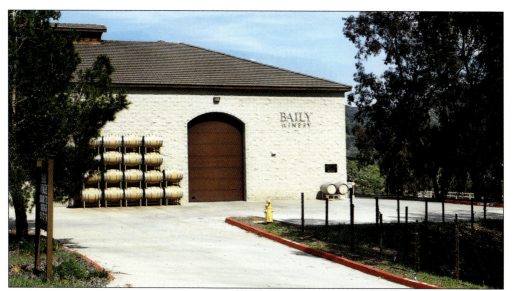

PAUBA TASTING ROOM. In 1986, Phil and Carol Baily built their first small winery on a dirt road not far from the De Portola Wine Trail. In 1992, they opened Baily Wine Country Café, which their son Chris and his wife eventually relocated to Old Town. In 1999, Phil and Carol built a new tasting room and restaurant on Rancho California Road. They also purchased, renovated, and sold another winery (now Falkner). With the profits, they built their current production facility on Pauba. (Courtesy of Baily Winery.)

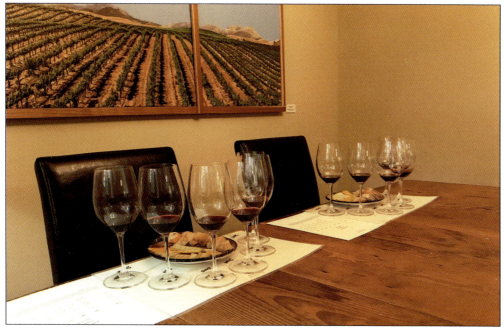

BAILY WINERY LIBRARY TASTING. Baily is the only winery in Temecula that retains sufficient quantities of its past vintages to allow it to offer "verticals" of its reserve wines every week; that is, wines of the same varietal (Cabernet Franc, Cabernet Sauvignon, and Meritage blends) but from different years. Available only on weekends at its Pauba facility, it is one of California's most unique and worthwhile wine experiences. (Courtesy of Baily Winery.)

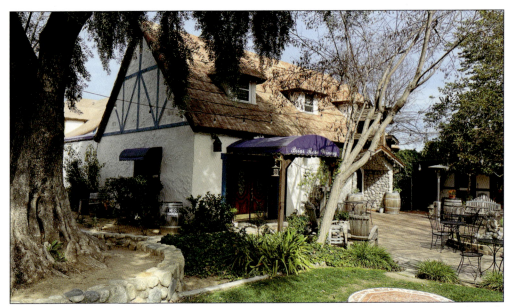

BRIAR ROSE WINERY. Opened in 2007 by Les and Dorian Linkogle, Briar Rose Winery is the only winery in the world that is a life-size replica of Snow White's cottage. The property was originally built by Beldon Fields, who helped design and build Disneyland in the 1950s. In the 1990s, the Linkogles planted Merlot, Viognier, Zinfandel, and other varietals. Eventually, winemaker Les and his wife, Dorian, turned their former house into a reservation-only winery. The enormous olive tree on the property was relocated from its former home at Callaway Winery by John Moramarco. (RC.)

WOOD-LINED TASTING ROOM. Les and Dorian Linkogle originally moved to Temecula to provide space for their son Larry "Link" to ride his motorcycle. As years went by, Larry developed into a pioneer of freestyle motocross and cofounder of the apparel company Metal Mulisha. Today, he lives on a property near his parents. A giant motorcycle ramp on the property testifies to his legacy. Briar Rose's signature wines are Cabernet Sauvignon and Zinfandel, though the winery offer a variety of reds and whites. (Courtesy of Briar Rose Winery.)

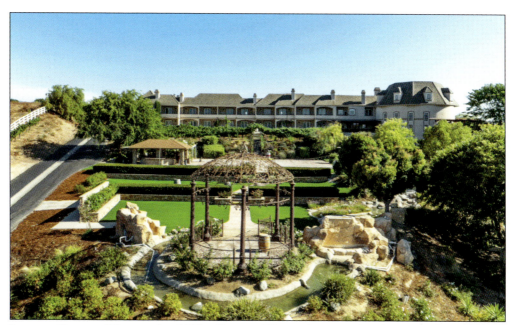

INN AT CHURON WINERY. In 2001, Churon Winery became the first to offer overnight accommodations to wine country visitors. Originally owned by two high school friends named Chuck and Ron (hence the name Churon), the 24-room chateau-style winery was purchased in 2018 by Jean Tong. The boutique hotel and its winery sit on a hillside surrounded by picturesque vineyards along Rancho California Road. (Courtesy of Inn at Churon Winery.)

BED, BREAKFAST, AND VIEWS. In addition to offering a wide selection of wines, Churon serves breakfast daily and lunches on weekends. A carved marble staircase takes visitors downstairs to the quaint tasting room decorated in murals. Veteran winemaker Tim Kramer currently heads Churon's wine program. With its beautifully maintained gardens, lawns, and gazebos, Churon is a popular wedding venue. (Courtesy of Inn at Churon Winery.)

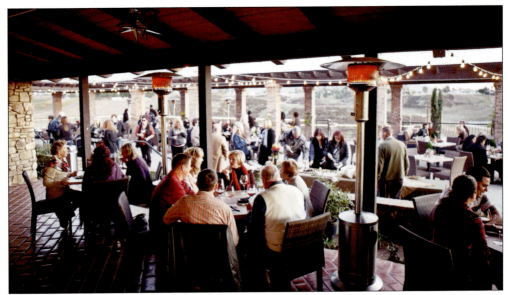

MIRAMONTE WINERY. Owned and operated by Cane Vanderhoof since 2000, Miramonte Winery began its existence as Piconi Winery, built in 1981 by Dr. John Piconi, one of wine country's pioneers. Vanderhoof and his partners have modernized and expanded the winery continuously over the past two decades, adding a new tasting area, covered veranda, and VIP spaces for their wine club in what was once Vanderhoof's home. With the help of well-known viticulturist Ben Drake (who passed away in 2018), Miramonte replanted its 13 acres to southern Rhone varietals like Syrah, Grenache, Mourvèdre, and Cinsault. In 2013, Spanish and Portuguese varietals were added to the wine menu. (Courtesy of Miramonte Winery.)

ENJOYING THE NIGHT LIFE. Miramonte Winery is known for its regular nighttime musical entertainment in its outdoor patio area. Other wineries have since followed its example. In 2015, the winery opened a popular on-site bistro that serves premium charcuterie, flatbreads, burgers, pesto, and other dishes seven days a week, all prepared by chef Doug Simms. Award-winning winemaker Reinhard Schlassa crafts the wines to pair perfectly with the dishes. (Courtesy of TVWA.)

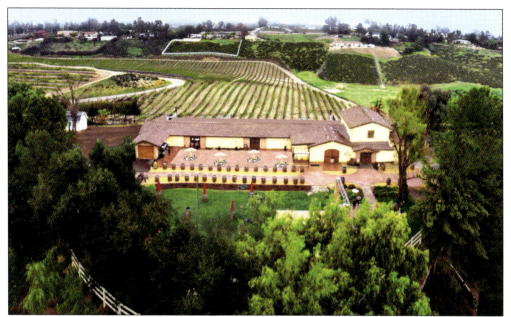

BEL VINO WINERY. Bel Vino straddles a ridge that allows for panoramic views of the Rancho California Wine Trail. Once a busy horse ranch, the tasting room, two outdoor patios, and large house (which is part of an integrated wedding venue) were completely renovated by owner Mike Janko in 2015. On weekends, the on-site bistro serves sandwiches, salads, and other light fare. Food trucks visit regularly as well. (Courtesy of Bel Vino Winery.)

PAIRING WINE AND MUSIC. Bel Vino caters frequent weddings and other events, such as concerts and dinners for wine club members. The tasting room has an expansive wine menu, with more than 25 varietals. Formerly Stuart Cellars, the 40-acre ranch was turned into a winery by veteran winemaker Marshall Stuart, who owned it until 2011. Stuart planted the vines in 1994 and made wine primarily from French varietals. In 2017, owner Janko doubled to 12 the number of varietals on the property. George Bursick now oversees winemaking operations, producing approximately 10,000 cases annually, including red, white, sweet, and sparkling. (Courtesy of Bel Vino Winery.)

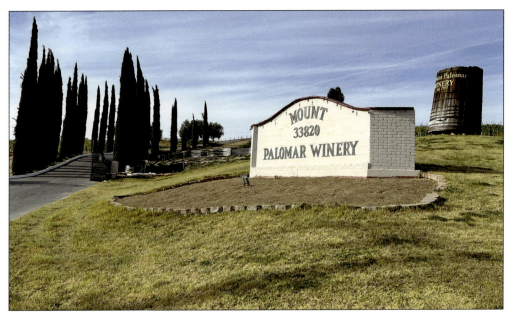

MOUNT PALOMAR WINERY. As the second-oldest winery in Temecula, Mount Palomar has gone through many changes over the years. In 1969, owner John Poole planted vineyards on his 165 acres at the same time Ely Callaway was planting out his own property. Poole's son Peter modernized winemaking at Mount Palomar. The Poole family sold the winery in 2006. In 2021, Mount Palomar sold again to a group of investors from nearby Hemet. (RC.)

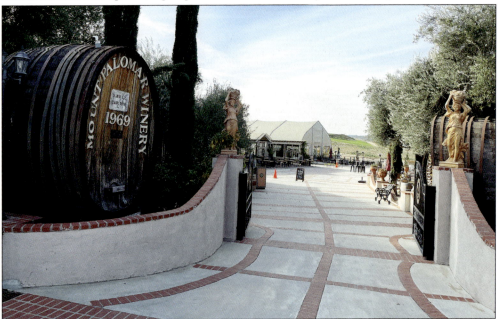

RENOVATION, RENEWAL, AND GROWTH. In 2021, the new owners of Mount Palomar Winery embarked on an aggressive renovation of the historic property and its surrounding acreage. In addition to planting thousands of new vines, they intend to build a larger wine-production facility and new guest areas, along with restaurants, shops, resort-style spa, and expanded wedding facilities. The restaurant now has a full-service bar. James Rutherford is in charge of winemaking. (RC.)

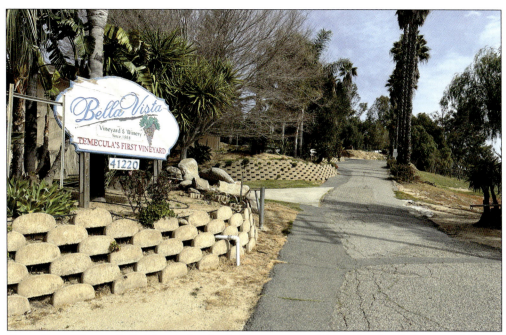

BELLA VISTA WINERY. Bella Vista is the third-oldest winery in Temecula after Callaway and Mount Palomar. It also boasts the first commercial vineyards. Opened in 1978 as Cilurzo Piconi Winery, it became Cilurzo Winery in 1979 when Dr. John Piconi started his own winery. Bella Vista acquired its current name in 2004 when the Cilurzos sold to Hungarian transplants Imre and Gizella Cziraki. The 40-year-old barnlike winery is located on 50 acres just south of the Rancho California Wine Trail on Calle Contento Road. With only five acres now in cultivation, Bella Vista still attracts a modest but loyal following. In 2022, Imre passed away at age 85. (RC.)

POND AND PICNIC AREA. Located above the rustic tasting room and production facility is a picnic area near a pond. For the first 20 years of its existence, the Cilurzo (now Bella Vista) property was the epicenter of wine country. These days, Bella Vista still has some of the most impressive views in Temecula. The winery makes small quantities of more than a dozen different varietals and blends, such as Cabernet Sauvignon, Merlot, Petite Sirah, Malbec, Sangiovese, and Viognier. (RC.)

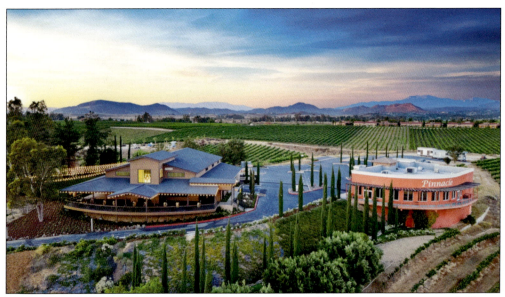

FALKNER WINERY. In 2000, Ray and Loretta Falkner opened their winery atop a majestic hill near the intersection of Calle Contento and Rancho California Roads. Formerly the site of Britton Cellars, the rustic wood facility hosted hundreds of weddings and produced an average of 6,000 cases of red, white, and sweet wines annually. In 2020, an electrical fire burned the winery to the ground. Undeterred, the Falkners rebuilt a similar but vastly improved structure on the old footprint, reopening to the public in 2022. The new 8,000-square-foot winery offers more seating inside and outside with even more dramatic vineyard and mountain views. (Courtesy of Falkner Winery.)

INSIDE THE TASTING ROOM. Since rebuilding, Falkner Winery has maintained its reputation for high-quality red, white, and sweet wines. Under longtime winemaker Duncan Williams, Falkner produces wines that are easy to drink and can complement food well. The winery's flagship wines are its Meritage red blend and a Super Tuscan. Falkner has been recognized by *Wine Enthusiast* magazine for more than a dozen wines with 90 plus or higher ratings. In addition to numerous membership events, tours and private tastings are available on weekends and by appointment. (Courtesy of Falkner Winery.)

**PELTZER FAMILY CELLARS.** Before building their winery in 2016, Carrie (far left) and Charlie (far right) Peltzer—the husband and wife owners of Peltzer Family Cellars—had already been hosting visitors on their property for more than two decades. Charlie is a fifth-generation farmer. The couple's two sons will be the sixth. In 1954, Charlie's family sold one of their farms in Orange County to Walt Disney. In the 1990s, they moved to the Inland Empire, settling on 25 acres on Calle Contento Road. Peltzer Farm has since become a Temecula institution, hosting an annual pumpkin patch, pony ride, petting zoo, corn maze, ice-skating rink, and other family-friendly activities. (Courtesy of Peltzer Family Cellars.)

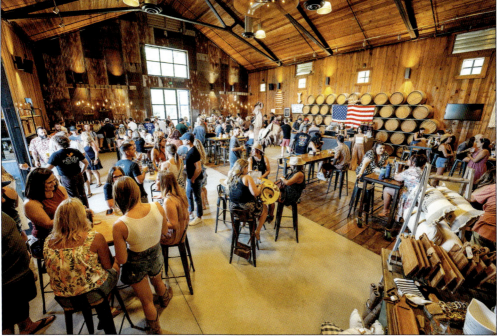

**THE CRUSH HOUSE.** In 2016, the Peltzer family expanded their agricultural business to winegrowing. They planted seven of their acres in three heat-tolerant varietals: Petite Sirah, Sangiovese, and Barbera. To make and sell their wines, they built a stunning, farmhouse-chic winemaking facility and tasting room just below their house. Known as the Crush House, the building now hosts winery goers, live music events, and weddings. Marshall Stuart is their winemaker. (Courtesy of Peltzer Family Cellars.)

LONGSHADOW RANCH VINEYARD AND WINERY. Longshadow is a family-owned boutique winery on Calle Contento Road just north of Rancho California. Since 1999, John Brodersen has served as both owner and winemaker. As a sixth-generation farmer, he takes the "ranch" part of his winery's title seriously. Several draft horses, sheep, and even a llama can be found on site. Longshadow is also one of the most family-friendly wineries in town. (Courtesy of Longshadow Ranch Vineyard and Winery.)

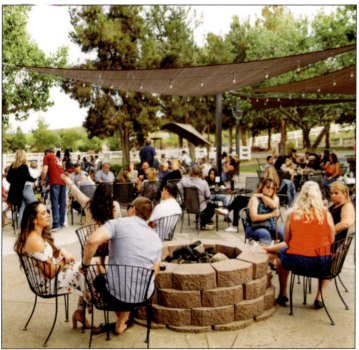

NO-NONSENSE WINES. At Longshadow, weekday wine tastings take place in the grove of eucalyptus trees and inside the elegant farmhouse-style building. Only outdoor wine tastings are available on the weekends. Weekends also mean food trucks and live music events. Most wines are made from fruit grown on the hillsides of the 25-acre property, including Cabernet Sauvignon, Cinsault, Syrah, Sangiovese, and other red varietals. (Courtesy of Paige Klingsporn/Temecula Life.)

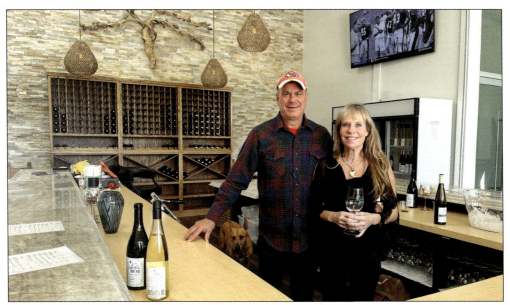

JULIE'S DREAM WINERY AND DISTILLERY. Formerly Alex's Red Barn, the property was purchased in 2019 by Julie Damewood and her father, Jerry Heiner. Julie and her husband, Doug, began a complete renovation and expansion of the existing facility. They also took out all the old, nonproducing vines and planted nearly 20 acres in new vines. Marshall Stuart is their consulting winemaker. Wines include Viognier, Riesling, Sauvignon Blanc, Vermentino, Cabernet Sauvignon, and others. The winery is also one of the few legal distilleries in wine country. (RC.)

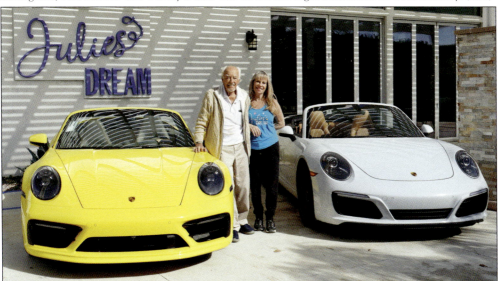

FATHER-DAUGHTER DREAM TEAM. Julie's Dream Winery and Distillery is on Calle Contento Road not far from the intersection of Rancho California Road. While Julie and Doug take care of day-to-day operations, Julie's 94-year-old father and co-owner Jerry visits regularly. In addition to the tasting room and production area, the large property has several rentable homes and a future venue for weddings and other events. Julie's sister Vicky and niece Amanda designed the winery's interior and its website. Best friend Trisha manages the entire estate, with stepdaughter Alexandra and son-in-law Colt helping out as well. (Courtesy of Julie's Dream Winery and Distillery.)

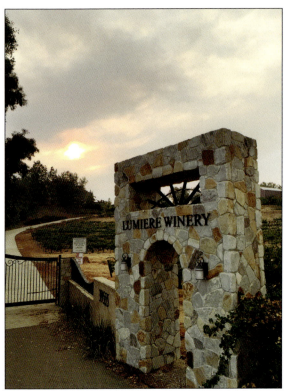

**Lumiere Winery.** In 1987, Dr. Ezra and Martha Kleiner, with their son Andrew and daughter Starlyn, purchased a 22-acre Sauvignon Blanc vineyard on the hills above Calle Contento Road. For 20 years, they sold their grapes to Callaway and other local wineries. But Ezra dreamed that one day Andrew would build a winery on the property and make wine. Ezra passed away in 2006, just before bud break on what became the winery's first harvest. Before he passed, however, he saw the future winery Andrew and Martha were diligently working to build. (Courtesy of Lumiere Winery.)

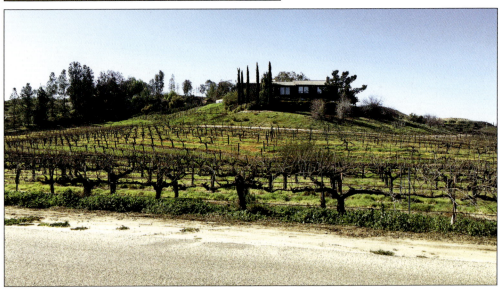

**Family-Run Vineyard Since 1987.** In 2010, Andrew Kleiner and his mother, Martha, finally opened the facility to the public. Today, Andrew oversees all operations for Lumiere, from winemaking to vineyard management. He is one of the only children of a wine country pioneer who is currently making wine in the valley. Martha manages the tasting room. Estate-grown Bordeaux-style wines are Lumiere's specialty. Varietals include Sauvignon Blanc, Merlot, Malbec, Cabernet Sauvignon, Cabernet Franc, and Petit Verdot. The tasting room is open Friday through Sunday between 11:00 a.m. and 6:00 p.m. (Courtesy of Lumiere Winery.)

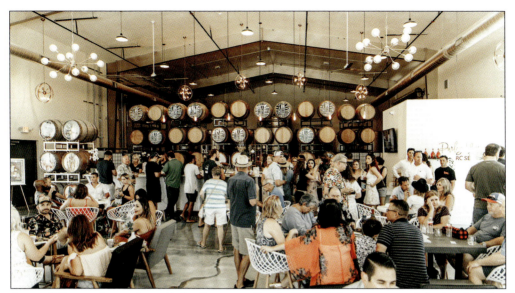

AKASH WINERY. Located on Calle Contento Road, Akash Winery is owned by hotelier Ray Patel; his wife, Nalini (who passed away in 2021); and their son Akash, after whom the winery is named. In 2010, the Patel family planted the first vines on their 20-acre property. Today, the white, 5,000-square-foot building serves as a production and tasting facility. Future plans call for a 40-bedroom resort with a pool, restaurant, and spa. The elegant Sky Lounge tasting room sports dozens of stacked barrels of wine, a quartzite tasting bar, and stylish white chairs and tables. (Courtesy of Akash Winery.)

THE PATELS AND THEIR WINEMAKER. As the only millennial with a winery in Temecula, Akash Patel (left) infuses his place with an energetic, hip, resort vibe. His co-owner father, Ray (center), brings to the table a passion for hospitality and years of business savvy. Renato Sais (right) makes the wines. Gorgeous sunset views are available from the outdoor seating area on the west side. Wood-fired pizza from Bocconcini is available on busy weekends. Sais crafts a variety of different wines, including red blends, rosés, and whites. (Courtesy of Akash Winery.)

VINDEMIA VINEYARD AND WINERY. Like many wineries in the valley, Vindemia began as a side project. Since the mid-1980s, owner and winemaker David Bradley has flown hot-air balloons professionally in Temecula wine country as the owner of California Dreamin' Balloon Adventures. In the late 1990s, he and his wife, Gail, purchased a 10-acre vineyard, most of which had been lost to Pierce's Disease in the late 1990s. They replanted the vineyard in several red varietals. In 2004, David began making wine, learning from a few of the area's most experienced winemakers. (RC.)

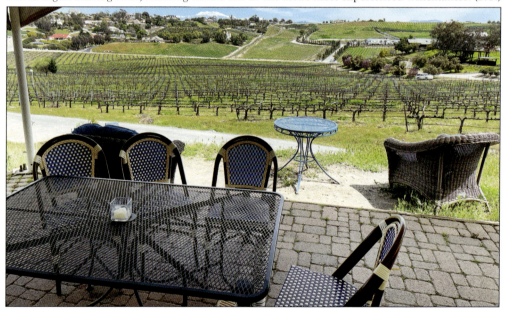

OUTDOOR TASTING AT VINDEMIA. Nestled on the rolling hills along Calle Contento Road with five other wineries, Vindemia Vineyard and Winery is a tranquil oasis. The atmosphere is no-nonsense and laid back. Vindemia is one of a half-dozen or so small, artisanal wineries in Temecula, producing fewer than 2,000 cases per year. Wine tastings are outside amid the rose bushes and olive trees, though there is a tent-like enclosure for shade. Winemaker and owner David Bradley makes several red wines, with Zinfandel, Cabernet Franc, Cabernet Sauvignon, and Grenache always on the menu. (RC.)

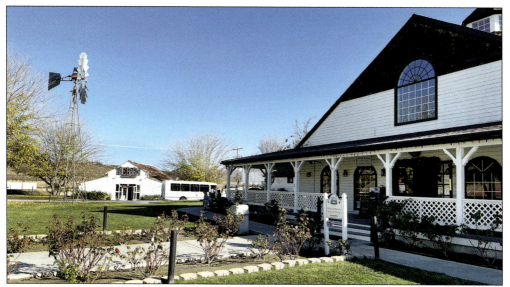

MAURICE CAR'RIE WINERY AND ULTIMATE VINEYARDS. Maurice Car'rie—which recently added "Ultimate Vineyards" to its name—is another example of how Temecula's past often blends with its future. The quaint, white, Victorian-style building, with its wraparound veranda, barn, windmill, and expansive front lawn, has been a wine country landmark since it was built in 1986. Some vines on the property date to 1968, making them among the oldest in the valley. In 2018, the Van Roekel family sold the winery to Corona-area businessman Janak Patel. The kitchen offers small bites, including panini, soups, salads, charcuterie, and its "world famous" sourdough baked brie bowls. (RC.)

HISTORIC YODER BARN. In some ways, Maurice Car'rie represents the birthplace of Temecula viticulture. The white barn and windmill are two of the oldest existing structures in the area, built by M.J. Yoder in the early 1900s as part of his barley operation. In 1968, Vincent and Audrey Cilurzo purchased the property, planting Temecula's first commercial vineyard. Owner Janak Patel has reverently restored the barn for special events and tastings. He also enclosed the lawn area to reduce road noise, created a new tasting room for members, and slashed wine production to focus on higher quality. (Courtesy of Ultimate Vineyards.)

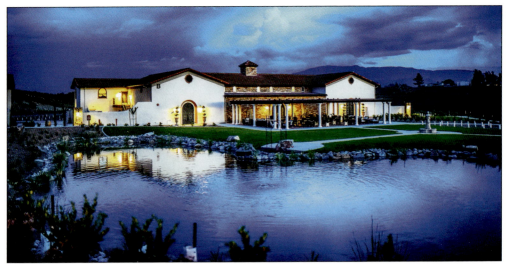

AVENSOLE WINERY. In 2014, the Lytton family purchased the 21-acre Van Roekel Winery on Rancho California Road, rechristening it Avensole Winery. The surrounding vineyards are among the oldest in the valley. Before Van Roekel, the complex of buildings was home to Mesa Verde Winery, one of first five wineries in the valley. After two years of intense renovation and site work, the Lyttons opened Avensole to the public in 2017. To the delight of visitors, they even added a pond to the stunning property. (Courtesy of Avensole Winery.)

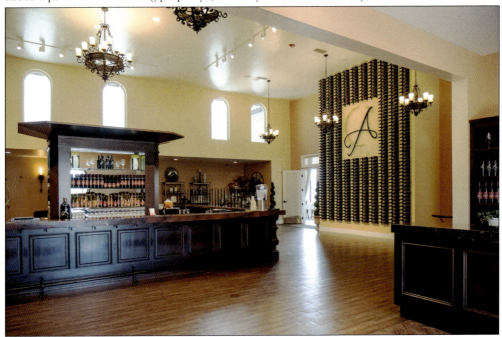

GRAND TASTING ROOM. The name Avensole is a combination of *avventura* (Italian for "adventure") and sole (meaning "one of a kind"). The Lytton family transformed the historic property into several gorgeous event spaces, tasting areas, and an award-winning restaurant. The 50-year-old barn is now a cathedral-like tasting room and event space, with a glass wall overlooking the production facility. The talented Renato Sais makes Avensole's wine primarily from estate fruit, including Cabernet Sauvignon, Muscat Canelli, Gewurztraminer, and Zinfandel. (Courtesy of Avensole Winery.)

**Lorimar Vineyards and Winery.** In 2009, brothers-in-law Lawrie Lipton and Mark Manfield started Lorimar's tasting room in Old Town Temecula. While the downtown location remains, in 2011 they opened a beautiful Tuscan-themed winery on 22 acres along Anza Road, just north of Rancho California Wine Trail. Lorimar's name derives from a mash-up of the owners' first names. (Courtesy of Lorimar Vineyards and Winery.)

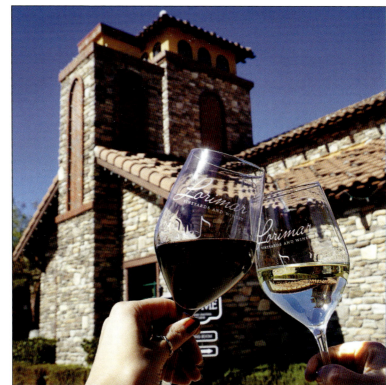

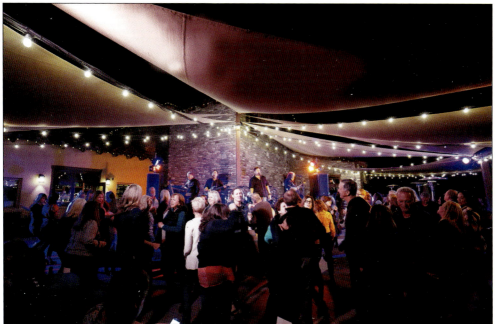

**Live Music Is Key.** Live music has always been integral to Lorimar's success. Lorimar might be the only place in Temecula with live music every day. Some wine bottles have a musical note on the label. Members and visitors enjoy a fusion of wine, art, music, and food. (Courtesy of Lorimar Vineyards and Winery.)

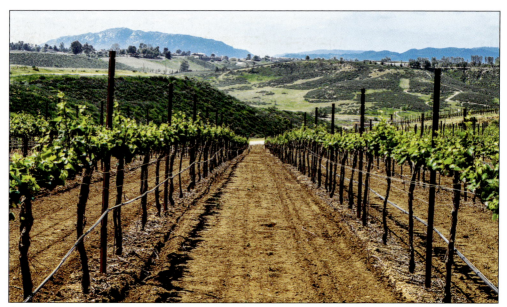

CARTER ESTATE WINERY AND RESORT. After the success of South Coast Winery Resort & Spa (which recently celebrated its 20th anniversary), Jim Carter built a sister winery across the street. In 2015, Carter Estate Winery and Resort opened its doors, along with 60 luxurious Mediterranean-inspired bungalows, a winery, a pool, and a bistro grill. The resort is located among 112 acres of vines on Rancho California Road. All wines are made from fruit grown on the property. Carter Winery offers small-batch production of reserve red and white wines in French oak and sparkling wines made in the *méthode champenoise* tradition. Sit-down tastings are encouraged. (Courtesy of Carter Estate Winery and Resort.)

JIM AND JEFF CARTER. Jeff Carter (right), son of founder Jim Carter (left), oversees operations of all the properties owned by the Carter Hospitality Group, including Carter Estate Winery and Resort, South Coast Winery Resort & Spa, and Carter Creek Winery Resort & Spa in Johnson City, Texas. (Courtesy of South Coast Winery Resort & Spa.)

**A Dynamic Winemaking Duo.** Carter Estate Winery and Resort utilizes the same production facilities and talented winemakers as South Coast Winery Resort & Spa, its sister winery next door. Both Jon McPherson (right) and Javier Flores (below) began their careers at Culbertson Winery in the mid-1980s. When Culbertson Winery became Thornton Winery, McPherson and Flores worked as a team, crafting sparkling wines in the *méthode champenoise* tradition. Jim Carter hired McPherson and Flores as his winemakers at South Coast Winery Resort & Spa in 2002. (Both, courtesy of South Coast Winery Resort & Spa.)

51

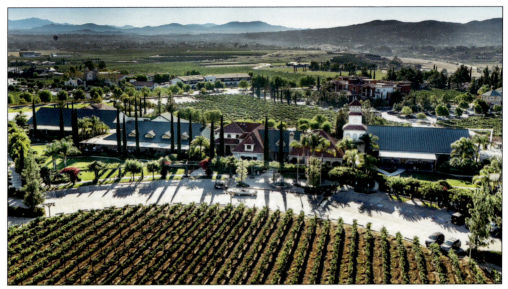

SOUTH COAST WINERY RESORT & SPA. In 1981, Jim Carter purchased 400 acres in the foothills of Mount Palomar east of Temecula. In the mid-1990s, after watching the popular film *A Walk in the Clouds*, he was bitten by the wine bug. He decided to plant vines on his land, which he dubbed Wild Horse Peak Vineyards. Ultimately, he bought 63 acres in the center of wine country near the intersection of Rancho California and Anza Roads. In 2003, South Coast Winery Resort & Spa opened its doors with the help of master winemakers Jon McPherson and Javier Flores. Since then, South Coast Winery Resort & Spa has set the standard for other winery resorts in Southern California. (Courtesy of South Coast Winery Resort & Spa.)

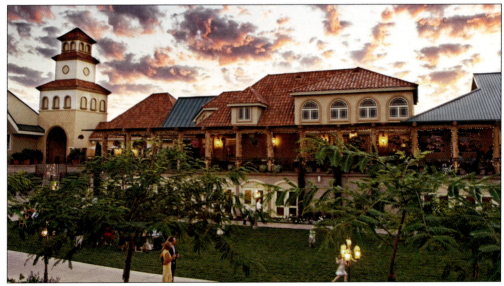

TEMECULA'S FIRST WINE RESORT. At around 45,000 cases annually, South Coast Winery produces more wine than nearly any other winery in Southern California. It offers a sit-down restaurant, a 132-room hotel, assorted luxury villas, meeting and wedding venues, and a full-service spa. It has won the California State Fair's Winery of the Year five times and has earned more than 3,000 awards for its wines. In 2015, the Carter family opened a boutique winery across the street called Carter Estate Winery and Resort. (Courtesy of South Coast Winery Resort & Spa.)

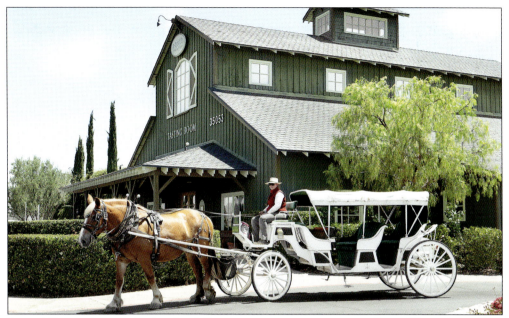

PONTE WINERY. As one of only a few full-service resorts in wine country, Ponte Winery has it all—a sit-down restaurant, conference rooms, hotel, bar, and a vast selection of wines. Opened in 2003, the buildings are part of a group of barn-chic structures that feature tasting rooms, an outdoor restaurant, a wedding and events building, a barrel room, and a wine-production facility. Ponte Vineyard Inn next door is a Spanish mission–style hotel with its own courtyard, restaurants, pond, the Cellar Bar, and pool area. (Courtesy of Ponte Winery.)

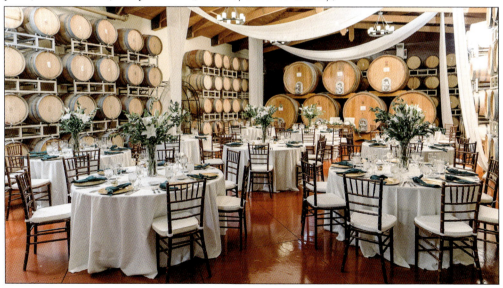

BARREL ROOM. In 2003, after two decades of growing grapes on his 300 acres, Claudio Ponte decided to go into the winemaking business. With ambitious visions, he built a tasting room, barrel room, winemaking facility, and open-air restaurant. In 2012, Ponte built a boutique hotel with 90 rooms and two on-site restaurants next door. With dreams of expanding the family estate, Ponte's vision came to life with the opening of a new boutique winery called Bottaia in 2018, less than a mile down the road from his flagship winery. (Courtesy of Ponte Winery.)

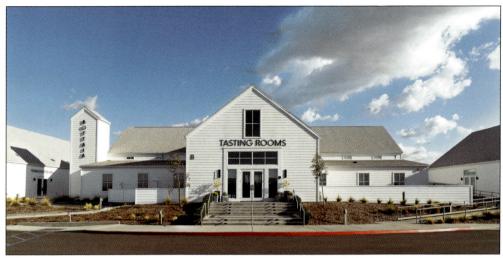

BOTTAIA WINERY. After the success of Ponte Winery, Claudio Ponte built a very different kind of winery on another part of his vast vineyards. Established in 2018, Bottaia is an upscale winery inspired by the luxury and refinement of northern Italy. Widely known for its iconic modern architecture, contemporary design, and monochromatic color palette, Bottaia is an Italian word meaning "cask-aging room." The vineyards surrounding the winery are planted in 15 different Italian varietals. Bottaia's nearly Olympic-sized pool creates an atmosphere of sophistication and luxury for all guests to enjoy. From their *cabines* (Italian-style private changing rooms) to dining at the Poolside Bar and Café, guests are sure to experience the dolce vita. (Courtesy of Bottaia Winery.)

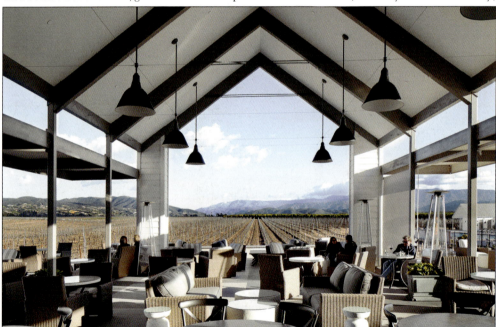

ENDLESS VINEYARD VIEWS. Bottaia's position on a plateau in the center of the valley offers unmatchable views of the vines from the outdoor terrace. The Pontes began as farmers, not vintners. In 1985, they purchased some of the area's original vineyards, planted by John Moramarco for the Brookside Vineyard Company in 1969. Eventually, the Pontes replanted most of these vineyards with Italian varietals such as Arneis, Montepulciano, Vermentino, and Sangiovese. (Courtesy of Bottaia Winery.)

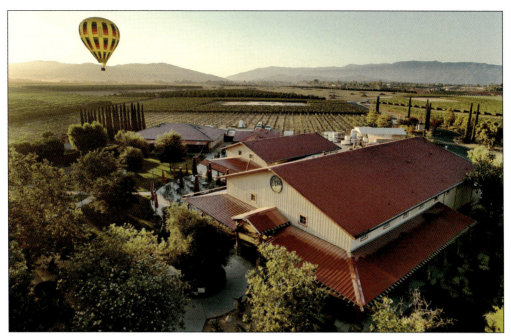

WIENS CELLARS. Wiens Cellars consists of a handful of red-roofed buildings at the center of the Rancho California Wine Trail. Outdoor patios offer views of the surrounding vineyards and the Palomar Mountains. Four Wiens brothers and their spouses founded the winery in 2001. One brother designed the structures, one built them, one tended the vineyards and made the wine, and one was in charge of daily operations. In 2006, they opened their tasting room. In 2022, Mark and David Steinhafel, a father-and-son team, purchased the property from the Wiens. The Steinhafels bring extensive retail experience developed over four generations. (Courtesy of Wiens Cellars.)

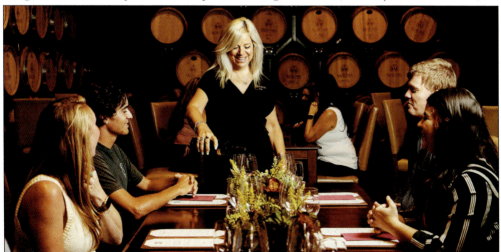

BARREL ROOM TASTINGS. On weekends, seated wine tastings in the barrel room are by appointment only and include a flight of Bordeaux-style reserve red wines. Wien's wine menu is vast. From the first 14-acre vineyard with five varietals in 1996, wine choices have expanded to the current 27 varietals over 150 acres of vines around the state. Joseph Wiens is in charge of winemaking. As new owners, the Steinhafels hope to build upon the strong legacy that the Wiens family created over 20 years. (Courtesy of Wiens Cellars.)

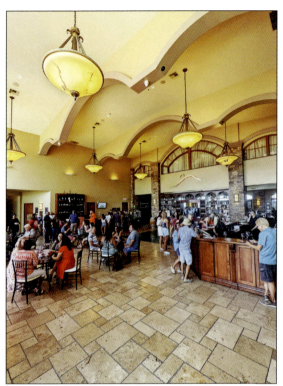

**MONTE DE ORO WINERY.** Founded in 2009 by 65 families in 27 different states, Monte De Oro represents a different kind of investment model from other wineries in town. Ken Zignorski is the general manager, overseeing the winery's ongoing success. David Allbright has crafted Monte De Oro's wines (mostly reds) for many years, helping garner 300 medals from various wine competitions since its founding. Nearly all wines are made from fruit grown on the winery's 72 acres of vines in the valley, including Malbec, Cabernet Franc, Syrah, and Tempranillo. The winery offers panoramic views of the valley. (Courtesy of Monte De Oro Winery.)

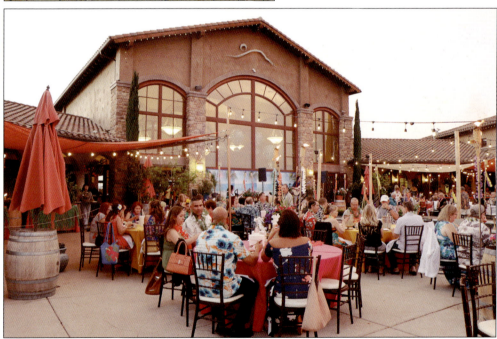

**PERFECT PATIO FOR PARTIES.** Monte De Oro's enormous patio has hosted many concerts, charity dinners, weddings, and member events over the years. At 21,000 square feet, the winery is as expansive as it is gorgeous. It features a weekend bistro, several tasting bars, and a central tasting room with a glass floor that looks into a massive cellar room. (Courtesy of Monte De Oro Winery.)

PALUMBO FAMILY VINEYARDS AND WINERY. As an artisanal winery, Palumbo Family Vineyards and Winery emphasizes quality over quantity, producing only around 1,200 cases per year. The tasting menu usually has five or six reds, among them Cabernet Franc, Cabernet Sauvignon, Grenache, Sangiovese, and Tannat. Most wines are made from fruit grown on the estate. Owner and winemaker Nick Palumbo ages his wine in barrel and bottle longer than most of his peers. (RC.)

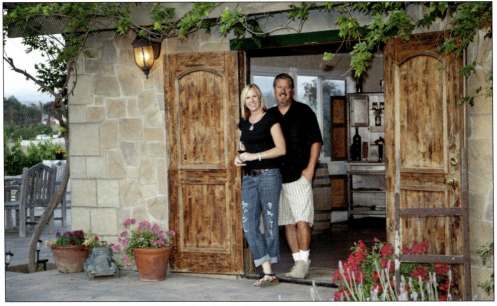

NICK AND CINDY PALUMBO. When Nick Palumbo's music career ended, he moved back to California to work as a chef in San Diego. On a weekend visit to Temecula, he fell in love with the idea of making wine. In 1998, he and his wife, Cindy, purchased a home on 13 acres of vineyards on Monte De Oro Road in wine country, embarking on a new career in grape growing and winemaking. Nearly a quarter century later, Palumbo Family Vineyards and Winery is still family owned, with grown children and spouses now working there. (Courtesy of Palumbo Family Vineyards and Winery.)

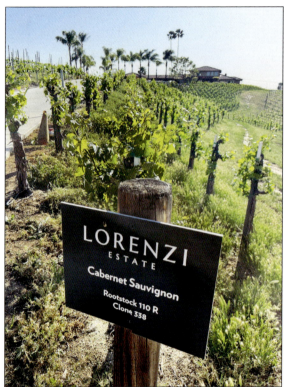

LORENZI ESTATE WINES. Situated on a hillside on Monte De Oro Road between Temecula's two wine trails, Lorenzi Estate Wines has been specializing in premium handcrafted wines since 2000. Winemaker and co-owner Don Lorenzi credits his Italian roots for inspiring him to make wine on his 16-acre property. He makes estate and non-estate wines from several varietals, like Cabernet Sauvignon, Chardonnay, Malbec, Petite Sirah, Syrah, and Zinfandel. (Courtesy of Lorenzi Estate Wines.)

DON AND BRENDA LORENZI. From the start, Don Lorenzi and his wife, Brenda, have run their winery as a team. Eventually, they were joined by their daughter Michelle. While Don makes the wine and manages the vineyard, Brenda oversees tasting room and wine club operations and Michelle heads up marketing and social media. Lorenzi is located on some of the original land planted by Brookside Winery in the late 1960s. (Courtesy of Lorenzi Estate Wines.)

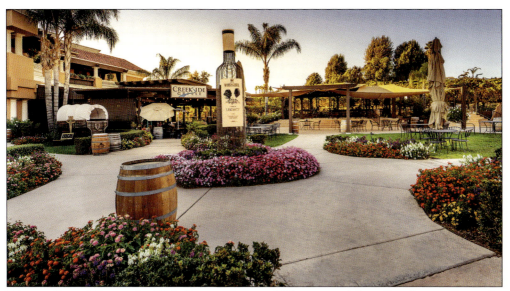

WILSON CREEK WINERY. In 1998, Rosie and Gerry Wilson moved from Pasadena to Temecula, purchasing 90 acres of vineyards near the end of Rancho California Road as a retirement project. Twenty years later, Wilson Creek is one of the region's largest and most popular wineries, with production facilities, wedding venues, convention spaces, a restaurant, a boutique hotel, and a two-story tasting building. Eldest son Bill Wilson oversees production of more than 43,000 cases annually. (Courtesy of Wilson Creek Winery.)

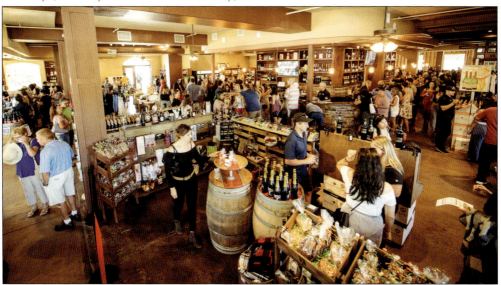

GIFT SHOP AND TASTING ROOM. As one of the busiest wineries in Temecula, Wilson Creek Winery is accustomed to large crowds. It has wide walkways, play areas for children, grassy lawns, and dozens of places to relax under terraces, tents, and umbrellas in its expansive courtyard. There are outdoor tasting counters, an upstairs member's lounge, intimate sit-down reserve tasting in the "library," large gift shop, two eateries, and a massive tasting room area. Gus Vizgirda and Kristina Filippi are in charge of winemaking. Vineyard manager Greg Pennyroyal leads the valley in regenerative agriculture, taking care of Wilson Creek's vineyards and others in the valley. He also mentors the Small Winegrowers Association. (Courtesy of Wilson Creek Winery.)

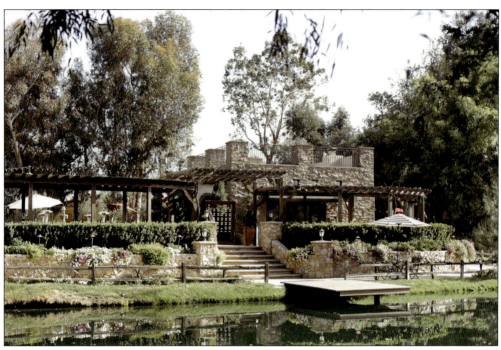

**VITAGLIANO WINERY.** In 2007, Frank and Lisa Aglio built their winery as part of their Lake Oak Meadows events center on Glen Oaks Road, just off the Rancho California Wine Trail. Frank named the winery after his grandfather Guy Vitagliano to honor his family's Italian roots and his passion for the wines of Italy. The estate's manicured grounds are said to resemble a postcard from Tuscany. A serene pond sits in the middle of the 10 acres. (Courtesy of L Parker Photography.)

**ROSÉ BENEATH THE EUCALYPTUS.** Visitors can purchase wine by the glass or bottle to enjoy in the outdoor tasting area. Estate varietals are Dolcetto, Cabernet Sauvignon, Pinot Grigio, and Muscat Canelli. Hours vary at the winery because of numerous weddings and other events. (Courtesy of Vitagliano Winery.)

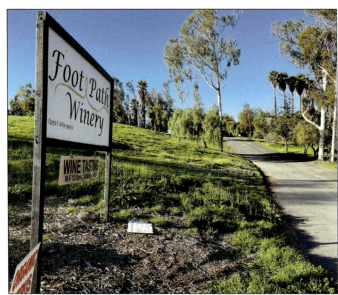

FOOT PATH WINERY. Driving onto Deane and Christine Foote's 20-acre property feels more like entering a farm than a winery. Grapefruit, lemon, lime, tangelo, fig, pepper, and olive trees abound. Visitors can purchase fruit in the same building in which they taste wines. All fruit (including grapes) is farmed organically. The tasting room and production facility are both housed in the large barn that dominates the property. Foot Path is among the smallest and most casual wineries in Temecula. (RC.)

CHRISTINE FOOTE WITH HER GRAPES. In 1999, after a career in corporate sales, Deane Foote and his wife, Christine, moved to Temecula from their home in Fontana. Back then, their acreage was planted almost entirely in citrus. They continued to sell their fruit and began to make red wine as a hobby. After planting their first vines in 2002, the hobby soon became a full-blown winery. For patrons who enjoy peace and quiet, tables are available for picnic lunches. (Courtesy of Deane and Christine Foote.)

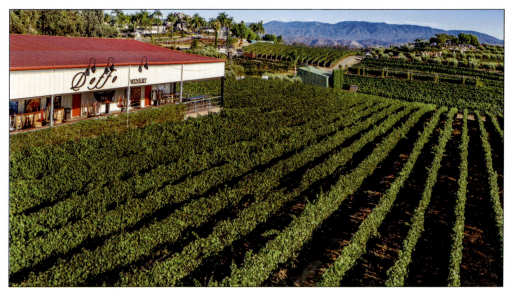

DOFFO WINERY. Marcelo Doffo's winery began modestly in 1997 in the family house on their 15-acre property near the end of Rancho California Road. Doffo soon converted the garage into a tasting room and started planting out the property in vines. Over the last decade, Doffo Winery expanded operations into an enormous metal building just west of the original tasting room. This structure holds the production facility, additional indoor and outdoor tasting areas, a gift shop, and a collection of more than 100 vintage motorcycles. Doffo Winery makes Malbec, Syrah, Cabernet Sauvignon, Petite Sirah, Zinfandel, and related blends using only estate-grown fruit. Nadia Urquidez is head winemaker, one of a handful of women in Temecula to serve in that capacity. (Courtesy of Doffo Winery.)

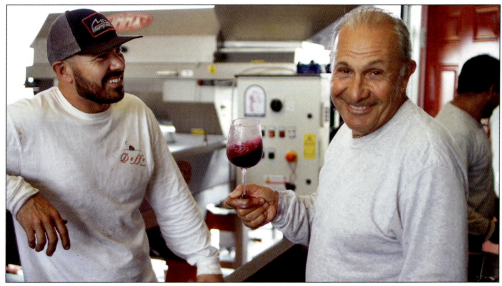

MARCELO AND DAMIAN DOFFO, PADRE Y HIJO. Born to Italian immigrants on a farm in Argentina's Pampas region, owner and winemaker Marcelo Doffo (right) left home in 1975 to seek his fortune in Southern California. Twenty years later, he purchased land on the former site of a 19th-century, one-room schoolhouse in eastern wine country. Son Damian (left) has taken over as general manager, while daughter Brigitte runs the tasting room and daughter Samantha coordinates winery events. In 2022, Doffo Winery celebrated its 25th anniversary. (Courtesy of Doffo Winery.)

CHAPIN FAMILY VINEYARDS. Chapin is a boutique winery five miles outside the city limits on the Rancho California Wine Trail. Its comparative isolation means sit-down tastings and a less crowded tasting room. Owner and winemaker Steve Chapin and his staff provide a consistently enjoyable wine-tasting experience, along with delicious wines, especially the Cabernet Sauvignon. Chapin produces around 4,000 cases every year. (Courtesy of Chapin Family Vineyards.)

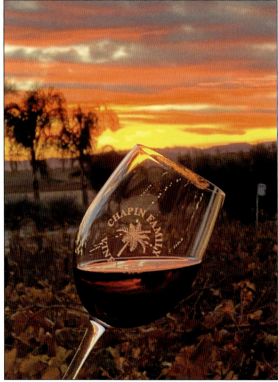

SUNSETS AND CABERNET SAUVIGNON. In 1987, Steve Chapin purchased 11 acres near Lake Skinner along a dirt road with no utilities. In 2002, he planted his first vineyards. For a time, he made limited amounts of wine for local hotels and restaurants, selling his fruit to other wineries. In 2011, he finally opened his doors to the public. For many years, Chapin was assisted by Enrique Ferro, one of Temecula's earliest winemakers. Today, Kristine Overlaur serves as assistant winemaker. Son Tim Chapin has taken over as operations manager. (Courtesy of Chapin Family Vineyards.)

RAUL RAMIREZ BODEGAS Y VIÑEDOS. Farming more than 45 acres of Spanish varietal wine grapes, Raul Ramirez Bodegas y Viñedos produces wines using the traditional methods of Spain. Wines include Spanish-style sweet sherry; several traditional table wine varietals of Tempranillo, Garnacha, Albarino, and Mencia; and others. Visitors can also taste bottle-fermented Cava-style sparkling wine. Tastings are by reservation only, Wednesday through Sunday, inside a modern chic building on a low hill overlooking Borel Road. (Courtesy of Raul Ramirez Bodegas y Viñedos.)

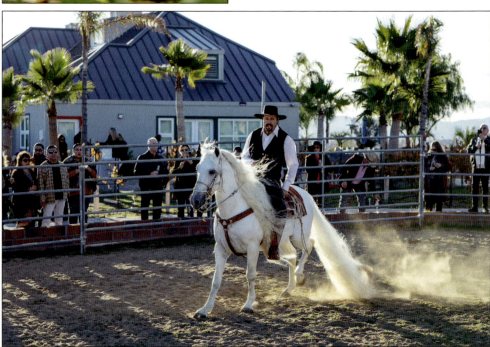

SPANISH WINES AND SPANISH HORSES. Situated in Temecula Valley wine country, the Raul Ramirez Bodegas y Viñedos tasting room sits on the highest hill of the ranch with a 360-degree view overlooking the vineyards and horses. The winery offers intimate sit-down tasting experiences with premium Spanish varietal wines. Members attend private events throughout the year. Events often feature the Andalusian horses stabled on site. (Courtesy of Raul Ramirez Bodegas y Viñedos.)

# Three

# De Portola Wine Trail

THE DE PORTOLA WINE TRAIL. The De Portola Wine Trail is south of Rancho California Road, with gorgeous views of Valle de los Caballos, so-called because of its many horse-breeding farms, and the Palomar Mountains. The trail begins at Anza Road and continues east for six miles, ending at Glen Oaks Road. Only a dozen or so wineries are located along its six-mile length. Wineries on De Portola Road tend to be newer, more laid back, and a bit more adventurous than those on Rancho California. For example, one will find Temecula's only wine cave, amphora winemaking, a Persian-style winery, Kosher-style wines, and a winery dedicated entirely to Italian varietals, among other pleasant surprises. (Courtesy of Oak Mountain Winery.)

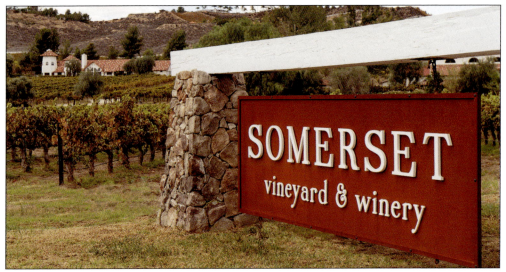

SOMERSET VINEYARD AND WINERY. Founded by brothers Kurt and John Tiedt in 2018, Somerset Vineyard and Winery represents a fascinating blend of Temecula's past and present. The 13-acre property—formerly known as Keyways Winery—was founded by Carl Key in 1990. It is the site of one of the experimental vineyards planted in the mid-1960s. Several well-known Temecula personalities passed through Keyways, including Terri Pebley (the first female owner-manager of a winery), Thom Curry (cofounder of the Temecula Olive Oil Company), and Don Frangipani (owner of Frangipani Estate Winery). There is also a stately house for rent on the property. (Courtesy of Somerset Vineyard and Winery.)

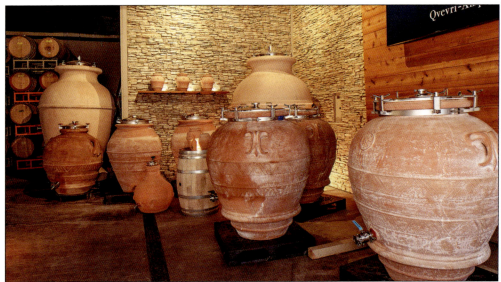

AMPHORA WINEMAKING. Owner Kurt Tiedt launched Somerset's groundbreaking new amphora winemaking program soon after opening his winery. Under the guidance of gifted winemaker David Raffaele, Somerset became the first winery in Southern California to produce wine using terra-cotta amphora vessels. The method goes back to a style of winemaking used by ancient Greeks and Georgians more than 5,000 years ago. Terra-cotta vessels are said to provide creamy, smooth, mineral flavors to red wine while allowing it to breathe during the aging process. Somerset actually owns two of the largest amphorae in the world. (Courtesy of Somerset Vineyard and Winery.)

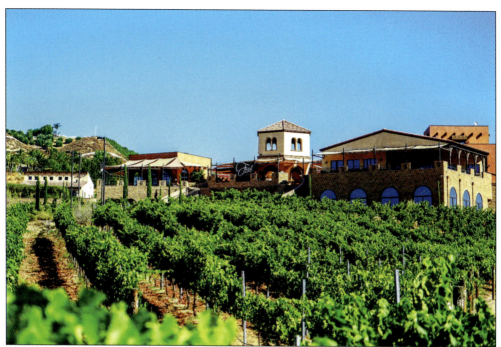

**Fazeli Cellars.** In 2015, Fazeli Cellars moved from its tasting room in Old Town Temecula to an impressive 22,000-square-foot modern Moorish-style winery on De Portola Road. With several tasting areas, a bistro-style restaurant, and several expansive patios overlooking the Valle de los Caballos, Fazeli is one of the area's more picturesque wineries. The winery currently produces 12,000 cases annually from more than 20 varietals, all farmed from local vineyards. Views from the six outdoor patios are stunning. (Courtesy of Fazeli Cellars.)

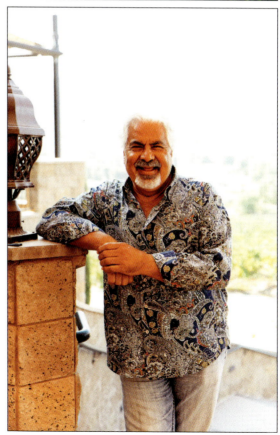

**B.J. Fazeli.** After successful careers in food, art, and marketing, entrepreneur B.J. Fazeli went into the wine business after a single visit to Temecula. Originally from Iran, Fazeli gives his wines Persian names that reflect the ancient winemaking tradition in the Middle East. Baba Joon's kitchen at Fazeli Cellars offers a variety of fusion Mediterranean food, such as braised lamb, hummus, dolmas, gyros and flatbreads, and salads. (Courtesy of Fazeli Cellars.)

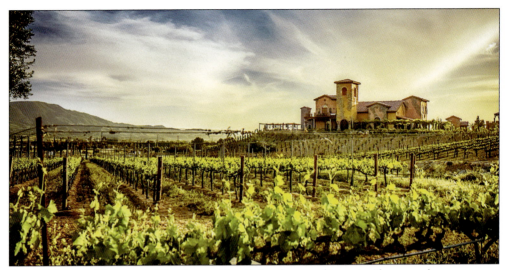

ROBERT RENZONI VINEYARDS. The Renzoni family has been making wine for more than a century, beginning with owner Robert's great-grandfather in Fano, Italy. Robert has been part of the wine and spirits business since his childhood. In 2008, he purchased 12 acres along De Portola Road. Ten acres are now planted with Pinot Grigio, Sangiovese, Montepulciano, and Barbera. Today, the winery produces 20,000 cases annually and 30 different wines inside a gorgeous Tuscan-style villa. The winery has an elegant tasting room, barrel rooms, a trattoria with a brick oven, an outside bar area, bocce court, and intimate brick-lined patios and picturesque picnic grounds. (Courtesy of Robert Renzoni Vineyards.)

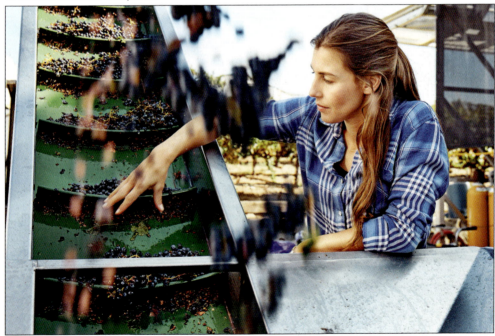

WINEMAKER OLIVIA BUE. In 2017, Robert Renzoni relinquished his longtime role as winemaker, elevating his former assistant, winemaker Olivia Bue, to the position. Today, Bue is one of only a few female head winemakers in the valley. A 2011 graduate of UC Davis in viticulture and enology, Bue worked in Napa Valley and Australia before joining Renzoni. (Courtesy of Robert Renzoni Vineyards.)

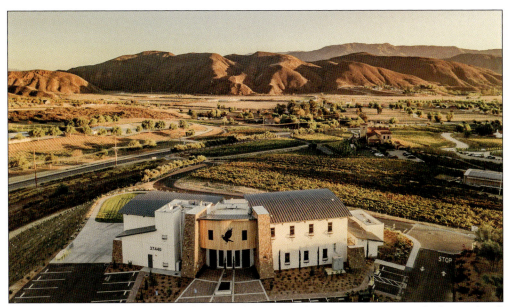

ALTISIMA WINERY. One of the area's newest wineries, Altisima Winery is perched on a knoll overlooking the Valle de los Caballos. After opening in 2021, the winery now produces around 8,000 cases annually, sourced from its own 20 acres of vines in addition to those of other Temecula properties. Through its wines, food at Gaspar's Restaurant, and striking architecture, Altisima celebrates Temecula's Spanish roots. The winery is owned by a few local families. (Courtesy of Altisima Winery.)

MAIN TASTING ROOM. Altisima Winery's central tasting room is a study in elegance and style. Thanks to its hilltop location, the winery has amazing views from its downstairs areas as well as from the second-floor members' lounges. Winemaker Chris Johnson and consultant Marshall Stuart make more than a dozen different dry and sweet wines from Grenache, Sangiovese, Mourvèdre, Sauvignon Blanc, and Pinot Grigio. (Courtesy of Altisima Winery.)

GERSHON BACHUS VINTNERS. Founded in 2005, Gershon Bachus Vintners is a boutique winery that sits atop a hill with astounding views. There are no food trucks, restaurants, or live music here. It is all about the wine. Servers are seasoned pros involved in every aspect of the winery, from the vineyard to the bottling line. The ambience is mellow and unpretentious. Since 2013, Dakota Denton has served as winemaker. The winery's estate reds are Cabernet Franc, Grenache, Zinfandel, and Petit Verdot. Syrah, Mourvèdre, and Malbec are sourced from their neighbors. (Courtesy of Gershon Bachus Vintners.)

WINES OF GERSHON BACHUS VINTNERS. Ken and Christina Falik are the husband and wife owners of Gershon Bachus. They may be the only proprietors in Temecula who actually live *in* their winery. The main part of their home sits directly above the former luxury car garage that now serves as the main tasting and reception area. Visitors are likely to find themselves sharing a glass of wine with the owners. Kenny named the winery after his grandfather, who immigrated from Ukraine in 1922. Gershon made wine as a hobby using knowledge he picked up in the Old World. (Courtesy of Gershon Bachus Vintners.)

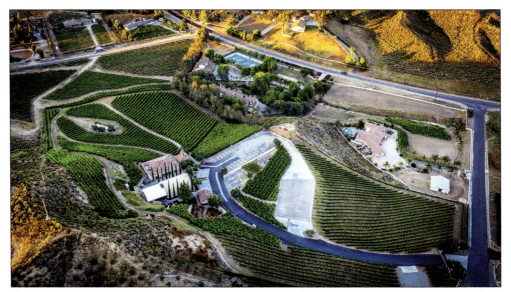

OAK MOUNTAIN WINERY. In 2005, Steve and Valerie Andrews purchased 10 acres on the side of a hill overlooking the valley. Having begun making wine at another facility nearby, they were able to hit the ground running when they opened Oak Mountain Winery. With Steve taking on winemaking and vineyard duties and Valerie in charge of everything else, the Andrews increased wine production and club membership every year. Eventually, they added an indoor and outdoor bistro-style restaurant, wedding venues, a stylish distillery, and—most spectacularly—a wine cave. (Courtesy of Oak Mountain Winery.)

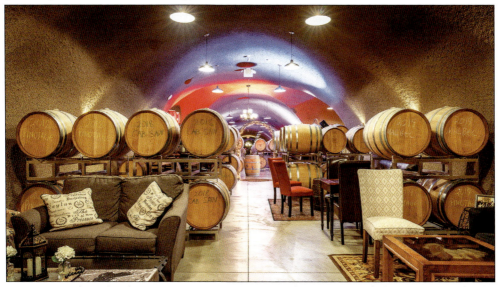

THE CAVE. When they began to run out of room for their guests and their wine barrels, the Andrews took the bold step of digging a massive wine cave in the hill behind the structure that had served as their tasting room. After years of planning and six months of drilling, Oak Mountain became home to the only mined wine cave in Southern California. At 10,000 square feet, the cave is large enough to fit a Greyhound bus or two. It serves as the main tasting room, wine cellar, kitchen, restaurant, and event space. In 2023, the Andrews sold their winery but will stay on as consultants. (Courtesy of Oak Mountain Winery.)

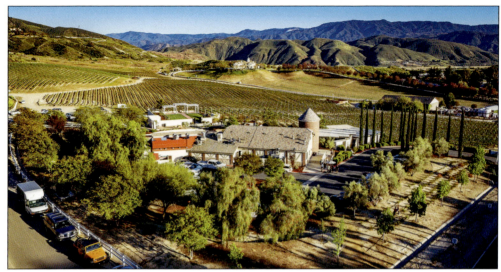

LEONESS CELLARS. Located on the De Portola Wine Trail, Leoness Cellars and its first-class restaurant gaze out onto 13 acres of rolling Cabernet Sauvignon vineyards with the Palomar Mountains behind them. In 1972, Gary Winder created a farm management company called Stage Ranch. In the late 1980s, Winder teamed up with Mike Rennie to open up what is now Leoness Cellars winery and restaurant. With a dynamic winemaker named Tim Kramer, Winder and Rennie began making wine from their own vineyards and those of their clients. (Courtesy of Leoness Cellars/Jimmy Fu Photography.)

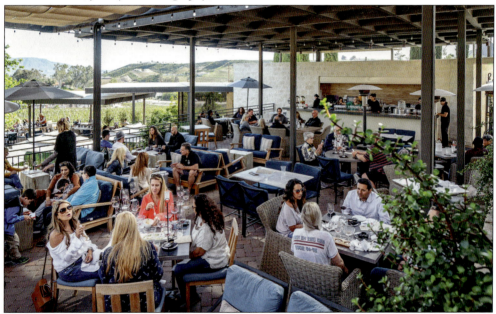

VINEYARD AND VALLEY VIEWS. Leoness Cellars is one of Temecula's busiest wineries, producing more than 15,000 cases annually and hosting weekly weddings and other special events. The winery makes its wines exclusively from its estate vineyards and from the many properties managed with Stage Ranch. Wines are typically made from at least 16 varietals, including Cabernet Sauvignon, Syrah, Zinfandel, Cabernet Franc, Grenache, Viognier, and Sauvignon Blanc. (Courtesy of Leoness Cellars/Jimmy Fu Photography.)

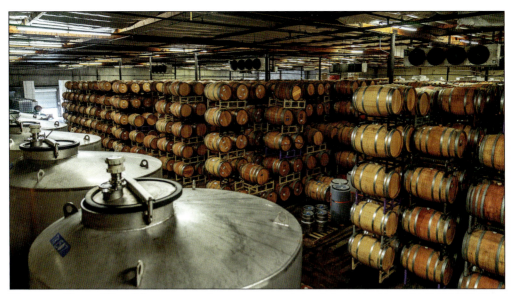

**TEMECULA VALLEY WINE MANAGEMENT.** In addition to being the founders of Leoness Cellars, Mike Rennie, Gary Winder, and their partners founded Stage Ranch Farm Management, Crush and Brew and Espadin restaurants, and Temecula Valley Winery Management (TVWM), a full-service winery management and development company servicing dozens of large and small wineries in the area. TVWM is the largest producer of wine in Southern California, crushing 1,300 tons (200,000 gallons) of wine grapes every year on average and managing over 6,000 barrels in its 30,000-square-foot facility in town. Rebaux Steyn serves as TVWM's CEO, and Tim Kramer is the director of winemaking. (Courtesy of Leoness Cellars/Jimmy Fu Photography.)

**TIM KRAMER, WINEMAKER.** After developing a passion for making wines at age 22, Kramer worked under some of the best winemakers in Southern California. Kramer was instrumental in the development of Leoness Cellars and has been its winemaker from the start. It did not take long for his winemaking talent to leave a big mark on the Temecula region. Over the last decade, he has received numerous 90-plus-point scores from publications such as *Wine Enthusiast* and *Connoisseurs' Guide to California Wine*. Kramer and his winemaking team have also won top medals at national and international competitions. (Courtesy of Denise Kramer Photography.)

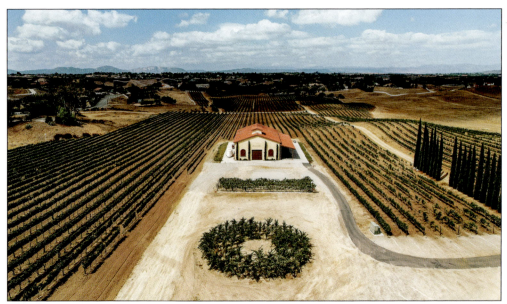

DANZA DEL SOL WINERY. In 2022, local businessman Ken Smith purchased Danza del Sol Winery and its sister winery, Masia de la Vinya Winery, from Bob Olson. Twelve years earlier, Olson had transformed the historic Filsinger Winery (built in 1980 by physician William Filsinger) into the popular Danza del Sol. Several buildings and patios on the property are regularly used for weddings and other public and private events. (Courtesy of Danza del Sol and Shelly Fingerlin.)

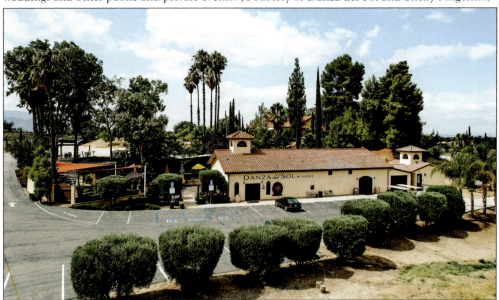

DEEP ROOTS IN THE LAND. Danza del Sol is home to many of the oldest vineyards in the area, some dating back to 1972. Several veteran winemakers have put their stamp on the wines of Danza del Sol (formerly Filsinger) over the years, including Mike Menghini, Mike Tingley, and Art Villarreal. New owners Ken and Tina Smith continue to utilize the talents of current winemaker Justin Knight to make estate wines from their 35 acres of vineyards. Cabernet Sauvignon, Cabernet Franc, Tempranillo, and Sauvignon Blanc are a few of the popular varietals grown on site. (Courtesy of Danza del Sol and Shelly Fingerlin.)

FRANGIPANI WINERY. Built by hand from the ground up by Don and JoAnn Frangipani, Frangipani Winery opened its doors as a boutique winery in 2006. As longtime grape growers, the Frangipanis wanted to make wine from fruit sourced mostly from their 10-acre vineyard. Winemaker and owner Don Frangipani learned how to make wine as cellar master at Cilurzo Winery (now Bella Vista) in the mid-1990s. Guests can enjoy counter and sit-down tastings, either inside the winery or on the shaded patio overlooking the vineyards. (Courtesy of Frangipani Winery.)

BOUTIQUE WINERY WITH A CASUAL VIBE. Don Frangipani makes only a few thousand cases of red and white wines every year, generally from his own estate-grown fruit. His passion is for French varietals, particularly Cabernet Franc, Malbec, Petit Verdot, and Cabernet Sauvignon. Limited snack offerings are available in the tasting room. Not surprisingly, the Frangipani flower (a type of plumeria) is the symbol of the winery. (Courtesy of Frangipani Winery.)

COUGAR VINEYARD AND WINERY. Owners Jennifer and Rick Buffington made wine for years as hobbyists in Texas and Washington. In 2006, they opened their winery at the end of the De Portola Wine Trail, naming it after Washington's Cougar Mountain. Cougar Vineyard and Winery exclusively makes Italian-style wines, offering more than 20 different red, white, and sweet wines, all made from Temecula fruit. (Courtesy of Cougar Vineyard and Winery.)

COUGAR BARREL ROOM. Members and tour groups often enjoy tastings in the barrel room. Besides wine, Cougar offers delicious Italian-style bistro food at reasonable prices. Most visitors opt to sit at one of the tables outside or in the Adirondack chairs to admire the vineyards and gorgeous valley views. Olive trees scattered about the property provide the oil that is sold in the small gift area. (Courtesy of Cougar Vineyard and Winery.)

**Cougar Tasting Room.** The vaulted interior tasting room is dominated by a long, L-shaped polished wood bar and a dozen tables. The winery is extremely dog friendly, with corkboards displaying Polaroids of members' pets. Charcuterie, pizza, sandwiches, and other casual dining fare is available at the in-house deli. (RC.)

**Jennifer and Rick Buffington.** In 2019, an international wine scholar recognized Cougar Vineyard and Winery as the only winery in the world to make wine exclusively from Lambrusca di Alessandria grapes, a black grape found in the Piedmont region of northern Italy. Like latter-day grape evangelists, the Buffingtons have been leaders in introducing several lesser-known Italian varietals to America. In 2020, they spearheaded the successful effort to get the varietal Ciliegiolo officially recognized by the Alcohol and Tobacco Tax and Trade Bureau. Cougar is also among the first wineries in America to grow Falanghina, Greco di Tufo, and other unusual wine grapes. (Courtesy of Cougar Vineyard and Winery.)

MASIA DE LA VINYA WINERY. In 2022, Ken and Tina Smith acquired both Masia and its sister winery down the road, Danza del Sol. The last winery on the De Portola Wine Trail, Masia specializes in Spanish-influenced wines served in a casual atmosphere either outside on the two large patios or inside in two indoor tasting rooms. (Courtesy of Masia de la Vinya Winery and Shelly Fingerlin.)

VINTNER'S LOUNGE. A separate entrance and elegant tasting area greet Masia's wine club members. The vintner of the Vintner's Lounge is Justin Knight, who is the winemaker at both of Ken and Tina Smith's wineries. Knight trained under several of the area's top winemakers, including Mike Tingley and Art Villarreal. Masia recently built a new production facility on the property. (Courtesy of Masia de la Vinya Winery and Shelly Fingerlin.)

## Four

# DINING IN WINE COUNTRY

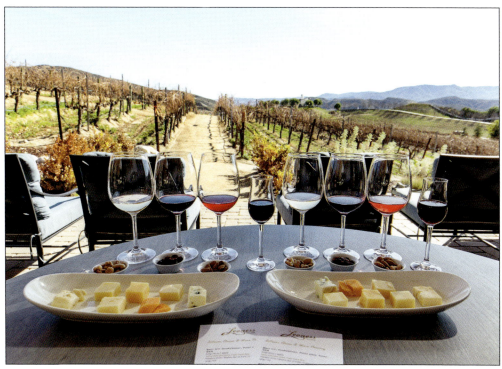

DINING IN THE VINES. For the first 30 years, Temecula wine country gave visitors few dining options. Since 2000 or so, however, new wineries have opened more than a dozen full-service restaurants. Still others offer food trucks, pop-ups, and other delicious alternatives. Few aesthetic delights surpass sipping a glass of Sangiovese or Sauvignon Blanc while devouring charcuterie or a bubbling slice of pizza. As wine scholar Michael Broadbent writes, "Drinking good wine with good food in good company is one of life's most civilized pleasures." What follows is not an exhaustive list of dining choices in wine country, but it is a good start. (Courtesy of Leoness Cellars.)

**CAFÉ CHAMPAGNE.** Thornton's award-winning Café Champagne was the first full-service fine dining restaurant in wine country when it opened in 1988. Today, it offers lunch and dinner seven days a week from 11:00 a.m. to 7:00 p.m. (9:00 p.m. on Friday and Saturday) in a casual but elegant setting. The menu specializes in contemporary cuisine with a French influence. For reservations, call 951-699-0088. (Courtesy of Thornton Winery.)

**BOLERO RESTAURANTE.** Bolero Restaurante at Europa Village offers award-winning and elevated tapas-style cuisine. Executive chef Hany Ali's menu takes guests on a culinary journey through Spain, from the humble farm-to-table cuisines of Asturias to the modern interpretations of San Sebastian and Barcelona. Family-style tapas is the rule, whether seafood, steak, roasted vegetables, olives, European cheeses, or charcuterie. Bolero is open seven days a week for breakfast, lunch, and dinner. For reservations, call 951-414-3802. (Courtesy of Europa Village and Joey Fink.)

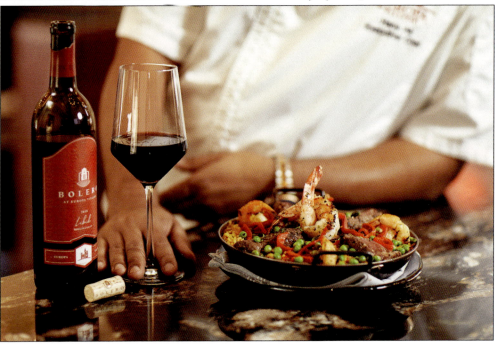

MERITAGE RESTAURANT. Meritage is Callaway Winery's full-service restaurant. It is an underrated gem specializing in farm-to-table dishes. Meritage offers lunch every day from 11:00 a.m. through 4:00 p.m. Lunch and dinner are served Fridays and Saturdays from 11:00 a.m. to 8:00 p.m. Dinner is also available Sundays from 11:00 a.m. to 6:00 p.m. For reservations call 951-587-8889. (RC.)

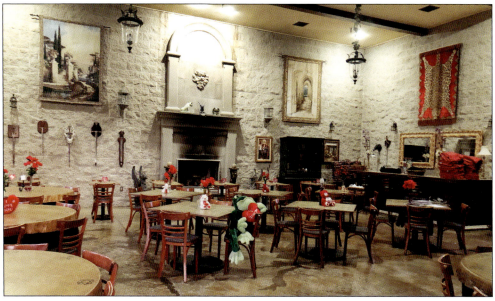

CAROL'S RESTAURANT. Baily Winery's restaurant is named after Carol Baily, co-owner with husband Phil and one of the pioneers of wine country. Carol created a decidedly medieval-themed restaurant, with stone walls, high ceilings, and a cavernous fireplace. Dine inside Bacchus Hall or outside under the pergola overlooking the vineyard. The luncheon menu has traditional sandwiches, classical salads, grilled meats, and fish. Baily's award-winning wines are also available, as are a selection of local beers. It is open for lunch Friday through Sunday. For reservations, call 951-676-9243. (Courtesy of Bailey Winery.)

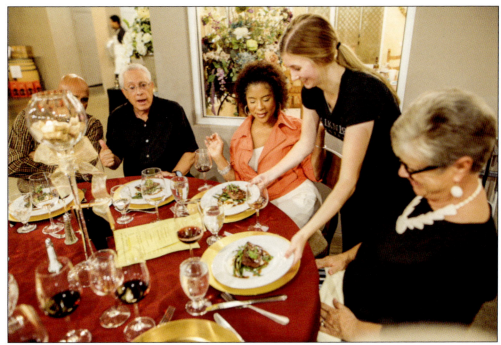

PINNACLE RESTAURANT. Since 2006, Pinnacle Restaurant at Falkner Winery has served Mediterranean-style cuisine seven days a week from 11:30 a.m. to 3:00 p.m. Floor-to-ceiling windows overlook 18 acres of vines, some of which are among the oldest in the valley. The barrel room sits underneath the restaurant. Like the winery next door, Pinnacle prides itself on top-notch service and excellent food. For reservations, call 951-676-8231, extension 4. (Courtesy of Falkner Winery.)

THE RESTAURANT AT AVENSOLE WINERY. The restaurant at Avensole has a wide selection of lunch and dinner fare such as sandwiches, flatbreads, duck, steak, and fish. There are evolving menus and award-winning wines in an alfresco setting. Overlooking a tranquil pond and vineyards, views from the patio enhance the dining experience. Avensole is one of only a few wineries that holds a full liquor license, allowing guests to pair a meal with their cocktail of choice. The restaurant is open on most days from 11:00 a.m. to 3:00 p.m., with extended hours on Fridays and Saturdays. For reservations, call 951-252-2003, extension 301. (Courtesy of Avensole Winery.)

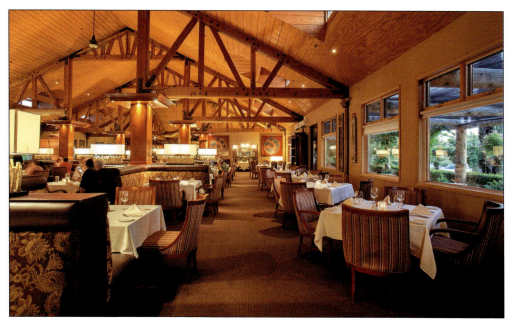

THE VINEYARD ROSE RESTAURANT. The Vineyard Rose Restaurant at South Coast Winery serves breakfast, lunch, and dinner seven days a week. Located in an elegant dining room with a wine bar and expansive patios, Vineyard Rose serves contemporary California cuisine sourced from farm-to-table ingredients. For reservations, call 877-743-8343. (Courtesy of South Coast Winery Resort & Spa.)

LORIMAR'S TUSCAN KITCHEN. Lorimar's casual "gourmet mobile kitchen" serves Italian-fusion lunch and dinner in its main courtyard. Chef Jorge Avarado pairs his dishes to enhance the flavors of Lorimar's wines. Typical dishes are flatbreads, charcuterie, salads, and pastas. Food is available from noon until 5:00 p.m. Sunday through Wednesday and from 11:00 a.m. to 9:00 p.m. Thursday through Saturday. For reservations, call 951-694-6699, extension 109. (Courtesy of Lorimar Winery.)

**THE RESTAURANT AT PONTE WINERY.** Ponte's award-winning Italian-themed restaurant is surrounded by stunning vineyards and manicured gardens. Outdoor dining is available year-round, Wednesday through Sunday from 11:00 a.m. to 7:00 p.m. The restaurant serves locally sourced produce; all natural, hormone-free meats; and wild caught or sustainably farmed fish. For reservations, call 951-252-1770. (Courtesy of Ponte Winery.)

**MONTE DE ORO BISTRO.** For a great wine and food experience, visit Monte De Oro Bistro. Chef Dre Magana provides a diverse fresh food portfolio, with gourmet salads, flatbread pizzas, panini sandwiches, great burgers, and other delectable seasonal offerings. With stunning 180-degree patio views of Temecula wine county, visitors can enjoy lunch or pre-dinner snacks with Monte De Oro's award-winning wines. Monte de Oro Bistro is open Thursday to Sunday from 11:00 a.m. to 4:30 p.m. The bistro's number is 951-491-6551. (Courtesy of Monte de Oro Winery.)

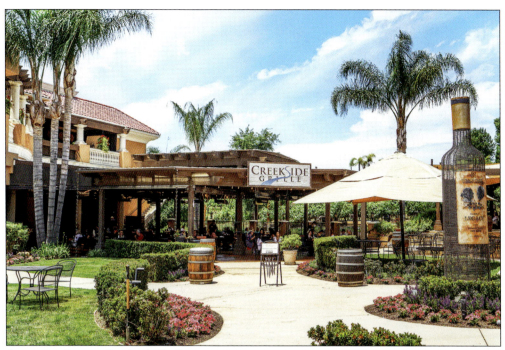

**CREEKSIDE GRILLE.** Creekside Grille at Wilson Creek Winery offers sit-down lunches in a friendly, outdoor setting among the vines. Executive chef Steve Stawinski's menu changes seasonally to take advantage of Temecula Valley's local produce. The more casual Courtyard Bar and Grill offers a limited menu for those wishing to enjoy a picnic-style lunch in the courtyard. For reservations, call 951-699-9463. (Courtesy of Wilson Creek Winery.)

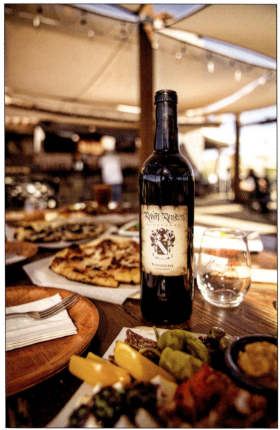

**MAMA ROSA'S TRATTORIA.** At Robert Renzoni Vineyards, Mama Rosa's Trattoria serves Italian food daily from 11:00 a.m. to 5:00 p.m. on a large, brick-lined patio overlooking the Valle de los Caballos. Specialties include brick-oven pizza, sandwiches, pastas, and a variety of appetizers. Most dishes come with recommended wine pairings. For reservations, call 951-302-8466. (Courtesy of Robert Renzoni Vineyards.)

BABA JOON'S KITCHEN. Baba Joon's Kitchen at Fazeli Cellars merges ancient Persia with contemporary California in a unique Mediterranean-Persian fusion menu. Owner B.J. Fazeli created some of the menu items himself, reflecting his passion for the art of cooking and wine pairing. Lunch fare is served between 11:00 a.m. and 5:00 p.m. on one of the many outdoor patios with jaw-dropping views. Shish kebabs, Persian tacos, gyros, and saffron shrimp are some of the favorites. For reservations, call 951-303-3366. (Courtesy of Fazeli Cellars.)

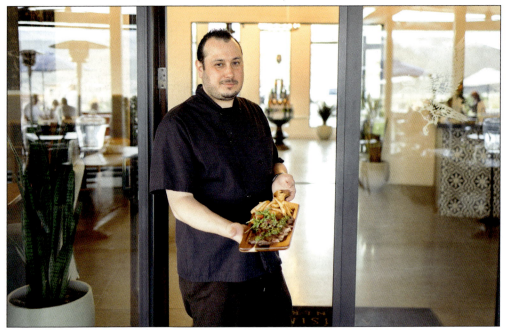

GASPAR'S RESTAURANT. Chef Morales poses with one of his creations. Gaspar's Restaurant at Altisima Winery offers modern cuisine with a Spanish flair. Gaspar's menu has tapas, salads, grilled meats, burgers, and seafood. Food can be enjoyed indoors or outside on the covered patio. For reservations, call 951-422-2525. (Courtesy of Altisima Winery.)

CAVE CAFÉ. The Cave Café at Oak Mountain Winery offers sit-down dining for lunch or snacks outside on its patio as well as inside its unique subterranean wine cave. The restaurant is open for dining Monday through Sunday from 11:00 a.m. to 5:00 p.m. Reservations are recommended for the weekends. The diverse menu emphasizes contemporary American fare, such as burgers, sandwiches, tacos, pasta, salads, and vegetarian options. (Courtesy of Oak Mountain Winery.)

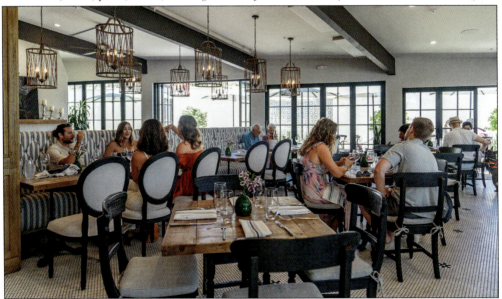

THE RESTAURANT AT LEONESS CELLARS. The award-winning restaurant and kitchen at Leoness Cellars serves lunch on weekends on its outdoor terraces with such favorites as pork belly tacos, hand-cut fries, lamb burger, charcuterie, and salads. Lunch and dinner are available inside the elegant restaurant from 11:30 a.m. to 7:00 p.m. Friday and Saturday and 11:30 a.m. to 5:00 p.m. Sunday. For reservations, call 951-302-7601. (Courtesy of Leoness Cellars.)

**SANGIO'S DELI.** Sangio's Deli at Cougar Vineyards and Winery offers casual dining from 11:00 a.m. to 6:00 p.m. seven days a week. The chefs craft the salads, antipasto, sandwiches, charcuterie, and pizza to pair perfectly with Cougar's Italian wines. Olive oil is made from olive trees on the property. The food is among the most reasonably priced in wine country. For reservations, call 951-491-0825. (RC.)

## Five

# OTHER TEMECULA ATTRACTIONS

BEYOND WINE COUNTRY. While many visitors in Temecula prefer to spend their time at the wineries and resorts, others prefer the other attractions the area has to offer. A quick list of fun things to do in Temecula has to include at least a few of the following: Visiting Old Town for dining and shopping, taking a ride in a hot-air balloon, going olive oil tasting, e-biking, horseback riding, hitting the links at one of the six local golf courses, or trying one's luck at Pechanga Casino, the most luxurious casino resort in the state. (Courtesy of the City of Temecula/Jason Stilgebouer and Dusty Summit.)

ENTERTAINMENT IN OLD TOWN. Weekends in Old Town Temecula mean live music and other entertainment. Until the mid-1960s or so, Temecula consisted mostly of the historic downtown area just west of I-15 between Rancho California and Temecula Parkway. In the late 1800s, Temecula (or Rancho California as it was sometimes called) began growing in earnest when the railroad was put in. Today, the charming streets of Old Town Temecula host numerous events and entertainment opportunities throughout the year, such as concerts, farmers markets, classic and street-rod car shows, arts and music festivals, western-themed heritage days, and cook-offs. (Courtesy of Brian Reilly.)

SHOPPING AND DINING IN OLD TOWN. While Old Town Temecula has managed to hold onto its historic charm, most of the buildings have either been built within the last decade or completely renovated. Rustic buildings from the early 1900s rub shoulders with new retro-style bistros, craft breweries, fine dining, speakeasies, rodeo bars, hotels, a live-arts theater, Temecula-made artisan shops, and other specialty boutiques. There are at least two dozen restaurants. Visitors will find homemade Italian cuisine; Mexican fare; farm-to-table innovative pub dining; locally sourced, organic, slow-food eateries; and pastry and coffee shops. (Courtesy of the City of Temecula.)

PECHANGA RESORT CASINO. It is ironic that the greatly reduced homeland of the Pechanga Band of the Luiseño Indians (whose reservation was created in 1882) should now be home to one of the largest Indian-owned casinos in the United States. Opened in 2002, Pechanga has 200,000 square feet of casino floor, with 5,400 slot machines and 152 table games. It also has 1,100 luxury rooms and suites; a two-level, 25,000-square-foot spa; and the Cove—a pool complex the size of five football fields. There are also a 1,200-seat theater, 3,000-seat events center, 15 restaurants and bars, and an 18-hole championship golf course. (Courtesy of Pechanga Resort Casino.)

THE COVE AT PECHANGA RESORT CASINO. Besides having two of the best restaurants in Temecula Valley (Great Oak Steakhouse and Umi Sushi & Oyster Bar), Pechanga Resort Casino also features a massive, 4.5-acre pool complex called the Cove, which consists of four pools, three whirlpools, two waterslides, a family pool, dozens of private cabanas, its own grill, and a swim-up bar. The Cove now offers day passes for non-hotel guests based on availability. (Courtesy of Pechanga Resort Casino.)

GOLFING IN TEMECULA. Golf has existed in Temecula since before the first wineries were built in the late 1960s. Today, there are six courses available for visitors and locals. The most difficult, beautiful, and expensive is Journey at Pechanga (shown here), which is located at the resort. However, other excellent courses abound, such as Cross Creek Golf Club in the western hills overlooking the valley and Temecula Creek Golf Club, which is the oldest course in the valley. (Courtesy of Pechanga Resort Casino.)

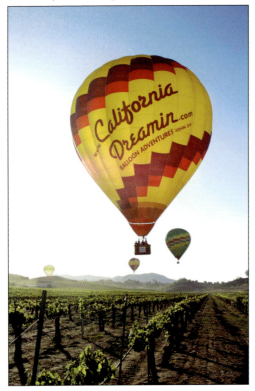

BALLOON RIDES OVER THE VINEYARDS. If visitors want to get above the wineries to view wine country from a more elevated point of view, a hot-air balloon ride is the best option. There are several companies that conduct balloon tours throughout the year. Thanks to Temecula's afternoon winds, rides take place only in the morning. If staying on the ground is a priority, there is always horseback riding or e-biking. For details on hot-air ballooning, horseback riding, biking, wine tours, and more, go to Visit Temecula Valley at www.visittemeculavalley.com. (Courtesy of Bryant Nelson.)

HORSEBACK RIDING IN THE VINES. Before Temecula was wine country, it was horse country. From the early 1900s until the mid-1960s, the Vail Company used the 87,000 acres around Temecula for grazing cattle and horses and for growing wheat and other grains. Several nationally recognized breeding and training facilities are in Temecula, mostly in the Valle de Los Caballos, the valley through which De Portola Wine Trail runs. Galway Downs is the biggest horse facility in the valley, hosting a range of events, from weddings to horse shows to music concerts. There are also several companies that lead horseback rides in Temecula, including Wine Country Trails by Horseback and CRC Trails by Horseback. (Courtesy of Wine Country Trails by Horseback.)

# Winery Index

Akash Winery (akashwinery.com), 45
Altisima Winery (altisimawinery.com), 69, 86
Avensole Winery (avensolewine.com), 48, 82
Baily Winery (bailywinery.com)32-33, 81
Bel Vino Winery (belvinowinery.com), 37
Bottaia Winery (bottaiawinery.com), 54
Bella Vista Winery (bellavistawinery.com), 39
Briar Rose Winery (briarrosewinery.com), 34
Callaway Vineyard and Winery (callawaywinery.com), 29, 81
Carter Estate Winery and Resort (wineresort.com), 50-51
Chapin Family Vineyards (chapinfamilyvineyards.com), 63
Cougar Vineyard and Winery (cougarvineyards.com), 76-77, 88
Danza del Sol Winery (danzadelsolwinery.com), 74
Doffo Winery (doffowines.com), 62
Europa Village (europavillage.com), 31, 80
Falkner Winery (falknerwinery.com), 40, 82
Fazeli Cellars (fazelicellars.com), 67, 86
Foot Path Winery (footpathwinery.com), 61
Frangipani Estate Winery (frangipaniwinery.com), 75
Gershon Bachus Vintners (gershonbachus.com), 70
Halter Ranch Temecula (halterranch.com/temecula), 28
Inn at Churon Winery (innatchuronwinery.com), 35
Julie's Dream Winery and Distillery (juliesdreamwinery.com), 43
Leoness Cellars (leonesscellars.com), 72-73, 87
Longshadow Ranch Winery (longshadowranchwinery.com), 42
Lorenzi Estate Vineyards and Winery (lorenziestatewines.com), 58
Lorimar Winery (lorimarwinery.com), 49, 83
Lumiere Winery (lumierewinery.com), 44
Masia de la Vinya Winery (masiadelavinyawinery.com), 78
Maurice Car'rie Winery and Ultimate Vineyards (ultimatevineyards.com), 47
Miramonte Winery (miramontewinery.com), 36
Monte De Oro Winery (montedeoro.com), 56, 84
Mount Palomar Winery (mountpalomar.com), 38
Oak Mountain Winery (oakmountainwinery.com), 71, 87
Palumbo Family Vineyards and Winery (palumbowines.com), 57
Peltzer Family Cellars (peltzerwinery.com), 41
Ponte Winery (pontewinery.com), 53, 84
Raul Ramirez Bodegas y Viñedos (raulramirezwinery.com), 64
Robert Renzoni Vineyards (robertrenzonivineyards.com), 68, 85
Somerset Vineyard and Winery (somersetvineyard.com), 66
South Coast Winery Resort & Spa (wineresort.com), 52, 83
Thornton Winery (thorntonwine.com), 30, 80
Vindemia Vineyard and Winery (vindemia.com), 46
Vitagliano Vineyards and Winery (vitaglianowines.com), 60
Wiens Cellars (wienscellars.com), 55
Wilson Creek Winery (wilsoncreekwinery.com), 59, 85

# BIBLIOGRAPHY

Barnett, Loretta, and Rebecca Farnbach. *Temecula*. Charleston, SC: Arcadia Publishing, 2006.

Engelhardt, Zephryin. *The Missions and Missionaries of California, Vol. 1*. San Francisco, CA: James H. Barry Company, 1921.

Farnbach, Rebecca, and Audrey and Vicenzo Cilurzo. *Temecula Wine Country*. Charleston, SC: Arcadia Publishing, 2009.

Heintz, William. *Temecula: A Grape and Wine History*. McMillan Farm Management (unpublished), 1981.

Heiser, Ralph. "Report on History of Wine and Brandy Manufacturing in California." Letter to John Moramarco, Callaway Winery, May 9, 1986.

Knight, Vick. *Toasting Temecula Wines*. Canyon Lake, CA: Artisan Press, 1999.

### General Information

De Portola Wine Trail: www.deportolawinetrail.com
Small Winegrowers Association: www.smallwinegrowersassociation.com
Temecula Life: www.temeculalife.tv
Temecula Valley Winegrowers Association: www.temeculawines.org
Temecula Valley Wine Society: www.tvwinesociety.org
Visit Temecula Valley: www.visittemeculavalley.com
WineCountry: www.winecountry.com

# Discover Thousands of Local History Books
## Featuring Millions of Vintage Images

Arcadia Publishing, the leading local history publisher in the United States, is committed to making history accessible and meaningful through publishing books that celebrate and preserve the heritage of America's people and places.

Find more books like this at
**www.arcadiapublishing.com**

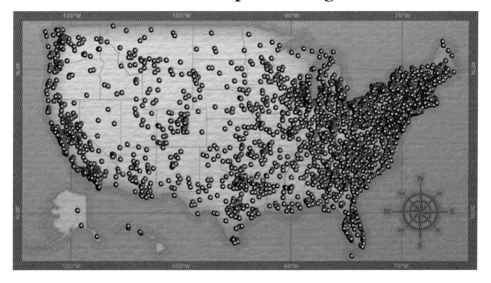

Search for your hometown history, your old stomping grounds, and even your favorite sports team.

Consistent with our mission to preserve history on a local level, this book was printed in South Carolina on American-made paper and manufactured entirely in the United States. Products carrying the accredited Forest Stewardship Council (FSC) label are printed on 100 percent FSC-certified paper.